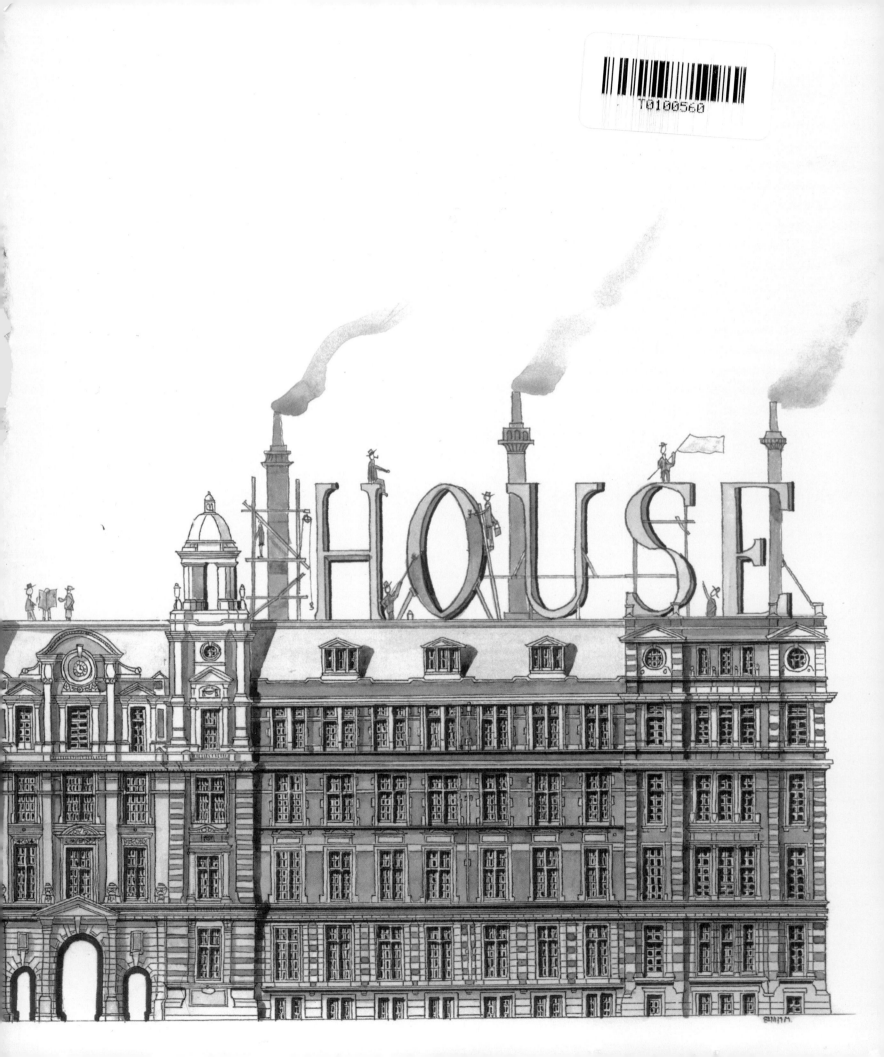

MEMORY
BANK

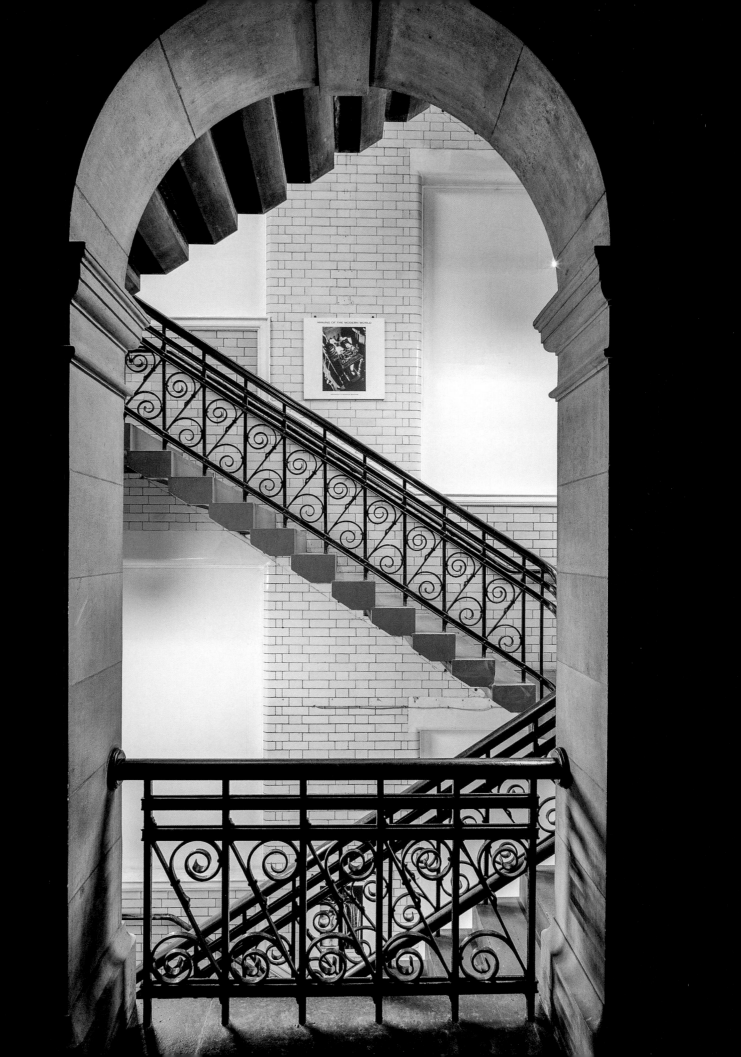

MEMORY BANK

A Biography of Blythe House

Laura Humphreys & Kevin Percival

SCALA

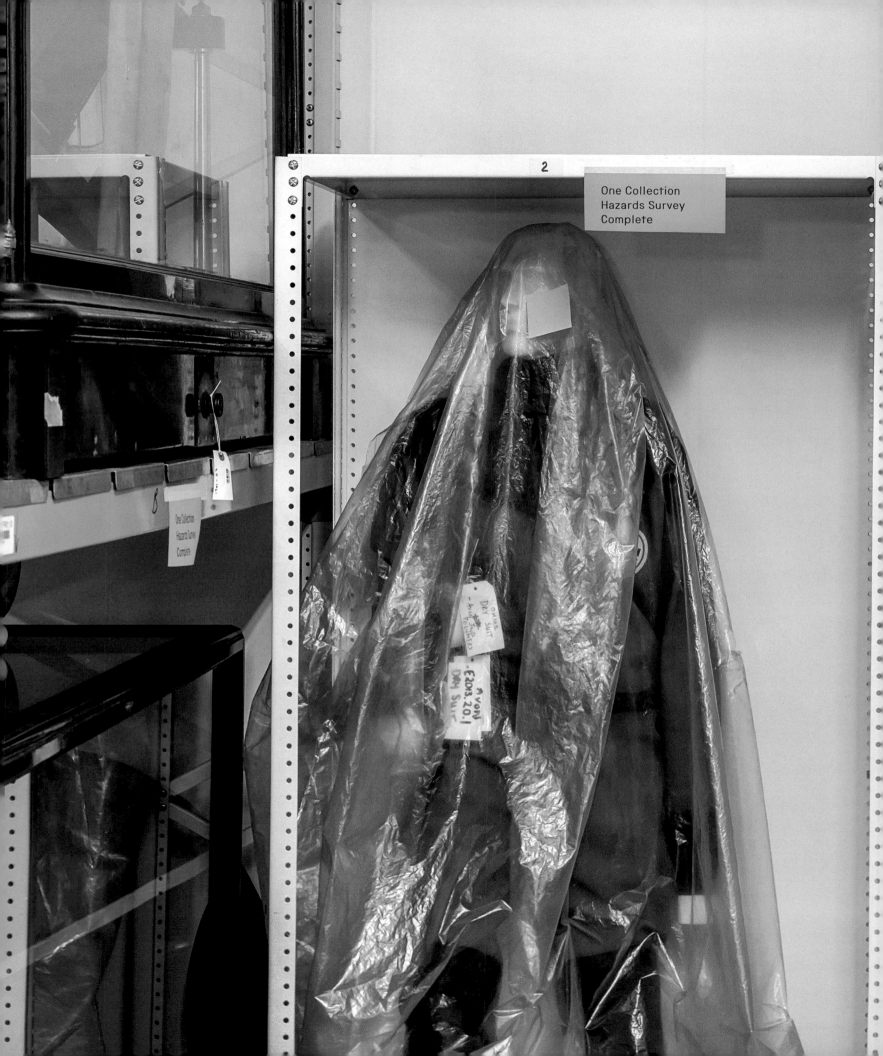

Contents

To Glenn Benson, without whom we would
know nothing about this incredible place.

A Brief History of Blythe House

> After the obligatory signing of the Official Secrets Act Declaration,
> we spent a week learning about the history, structure and operation
> of the Savings Bank.
> — Muriel Harding

Blythe House is an incredibly secretive building. Enormous and looming from all angles, but surrounded by other tall buildings, so you can never see a full elevation, or get a true sense of its vast size. It gives the impression of a building that was designed to be seen from a grand approach, but it is, and has long been, hemmed in by Hammersmith, Olympia and Shepherd's Bush on all sides. Considering its three hundred-plus rooms over six floors on a 5-acre site, it is exceptionally easy to miss.

In the late nineteenth century, Chief Architect of the Office of Works Sir Henry Tanner was commissioned to design a new Post Office Savings Bank. Tanner was responsible for post and telegraph buildings, although the Post Office Savings Bank (POSB) was to be one of his largest. The Bank was established by an Act of Parliament in 1861, but by the late nineteenth century had grown to such an extent that it required an ambitious new headquarters. Land was purchased on the border of Hammersmith and Kensington, and Blythe House was begun with the laying of a foundation stone by the Prince of Wales in 1899. By the time it was finished, he was King Edward VII. Blythe House was a late Victorian idea, completed in the Edwardian era, straddling the end of one world-changing century and the beginning of another. And in many ways, it was groundbreaking. Tanner was an early pioneer of concrete use, having served for two years as the President of the Concrete Institute. He was particularly interested in fireproof constructions made from the material, and employed it for parts of Blythe House only one year after the first use of ferro-concrete in Britain, at the Weaver Flour Mill in Swansea, which opened in 1898.

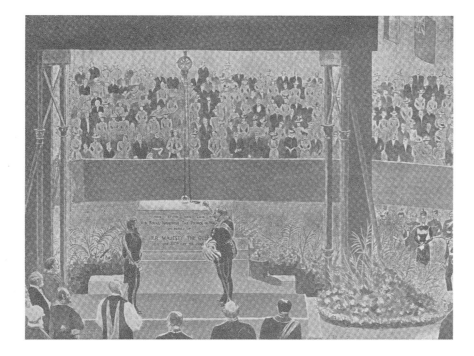

A commemorative engraving of the laying of the foundation stone of the Post Office Savings Bank by the Prince of Wales, 1899.

Tanner pointed to the success of reinforced concrete (and to a later use at the General Post Office, another of his works) to advocate for its wider adoption among British architects, warning that those who did not embrace it would be 'relegated to interior decoration and external design'.[1] Tanner's work on Blythe, however, showed that form and function could coexist, marrying the highly decorative Edwardian baroque of its exterior with the cutting-edge strength of steel-framed breeze concrete construction inside.

One of the restaurants on the fourth floor of the Post Office Savings Bank, which featured in a photo spread in *The Graphic*, 15 August 1903.

Such was the occasion when this new Post Office Savings Bank opened that it featured in a full-page spread in *The Graphic*, along with several photographs and the Bank's vital statistics: 'It is fitted up throughout with every modern comfort and convenience for the vast staff', including five electric lifts and three 'handsome' restaurants.[2] Later in its life, Blythe House would also have a rifle range on its roof, paid for by staff subscription.

The Post Office Savings Bank was designed with room to grow: there was both space and design for two extensions to be added to the east and to the west. Only the East Range was ever completed, in the early 1920s, between Blythe House and the Sorting Office on Blythe Road (also by Tanner). Loosely based on Tanner's original floor plan, and although in broad keeping with the main façade, the extension is noticeably pared back, with a mansard roof and clean, unfussy lines facing outward. Facing inward to the courtyard, it is all plain, painted white brick, reflecting a different age of utilitarian government architecture.

ONE OF THE DINING-ROOMS

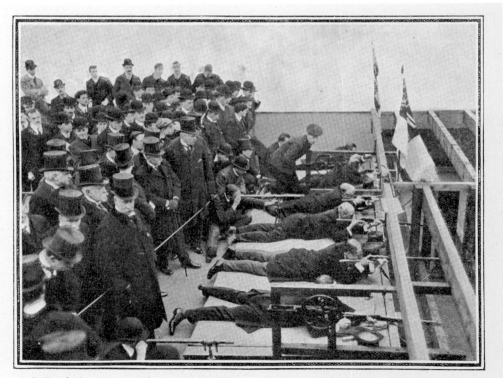

The rifle range on the roof of Blythe House on the day of its opening in 1907.

On Saturday last a miniature rifle range was opened on the roof of the Savings Bank building, West Kensington, for the use of the Post Office Officials' Rifle Club, which consists of nearly 500 members. The range was formally opened by Lord Granard, who fired the first shot and scored a bull's-eye.

The Post Office Savings Bank had expanded from its humble beginnings in a single room at the General Post Office, and continued to grow through the first half of the twentieth century. When it opened in 1903, it employed around 4,000 people at Blythe House.[3] More than 9 million British people had deposits at the Bank, from all over the country. The success of the Bank can, in part, be attributed to government policy. Founded at a time when Britain's banking system was largely unregulated and aimed at the wealthy, it was designed as a place for the lower and middle classes to be able to deposit small sums of money safely. The government was keen to encourage saving among the working classes as a safeguard against future unemployment or ill health. A government-backed bank offered this opportunity to most, especially as post offices (and the communication infrastructure between them) already existed throughout Britain. Transactions were made at a minimum of one shilling, but withdrawals could not usually happen on the same day. A depositor would have to send a letter off to London – to Blythe – to apply for a warrant. As long as funds were available, this warrant would be granted for a post office nominated by the depositor to release their funds.

By the 1920s, business had grown significantly again: a quarter of the UK's population were depositors at the Bank, with more than 12 million accounts totalling £283 million. The staff numbers at Blythe House had now reached 5,000.[4] By this point, however, there was criticism of the expense involved in running a large, centralised bank, which was processing many thousands of transactions per day at huge cost: 'By far the biggest savings in data-processing costs came from the use of low-grade labor for low-grade tasks, and the employment of women, boys, and girls.'[5]

An early Post Office Savings Bank Book, c.1910s.

A Home Safe in the shape of a book, which POSB savers were encouraged to use to keep their Bank Books secure.

From its opening, the Post Office Savings Bank was a significant employer of women, and it has been lauded for this in some quarters. More than 1,000 of the original employees were women,[6] and this number grew with time, particularly during the two world wars. The experience of many women working at the Bank, however, was difficult.

> This entrance on [the] side here was, in my day even, known as the old women's entrance because the women used that one and the men used the main entrance. Until the beginning of the war, when they had to change the rules, obviously. The women weren't allowed to set foot inside the place unless they were wearing stockings and a hat and gloves ...
> Even on the hottest day, no bare legs.
> – June Fenwick

Women were not welcomed to the POSB by all: the large-scale employment of 'lady clerks' was said to 'inflict a heavy blow on the male staff' in 1907.[7] Numerous accounts of dissatisfaction and industrial action were serious enough to make the national news. As well as being given shorter lunch breaks than men and not being allowed to speak while working (something that lasted well into the 1940s), women were

Some of the staff of the Ledger Branch, c.1913.

paid significantly less than men, had to meet higher standards to achieve a pay rise, and were held back from promotion within the Bank and in the wider Civil Service. On the occasion of Ledger Branch 102 being 'handed over' to women clerks, resulting in the redundancy of 22 men and the redeployment of 80 more, the Controller of the Bank made his feelings clear: 'The Controller softened the bitter pill by advising the men that he had long considered the mechanical routine of the Ledger Branch beneath the intelligence of the men who had passed the Second Division Examination, whilst it was peculiarly fitted to the lower ability of the women.'[8]

In 1919 there was a strike of canteen workers. These were contracted staff who did not work directly for the Civil Service, but it was widely reported that 80 women walked out of their work in the Bank's restaurants in protest at low wages, withheld service charges and failure to recognise their union or meet with a union representative. The strike was supported by the National Federation of Women Workers, and included a picket at Blythe Road. So, although the Bank was heralded in many quarters as an early mass employer of women, its first decades were beset by unfair treatment and unrest in the workforce, which continued until at least the mid-twentieth century.

> All junior staff were kept in their place, but girls particularly. And you know, before the days of equal pay and that kind of thing, I can remember the rows, real rows in the section, when we got equal pay which was phased in over seven years. But it did make a huge difference. You know as women, we moved on little duties within a section, you taught the person who was taking over from you. Goodness knows how the situation turned up, but we just discussed pay. And I was, I think, 18. And he was 10 years older and

we had pay scales that were 10, 11, 12 years long. And then there was the differential between the male and female pay. And I found aged 18 and female, he was male and 28, his take-home pay was two and a half times mine, for the same job. And at that point, the iron entered my little soul. So, I became a fighter for the cause, wouldn't you?
— June Fenwick

The Bank saw out two world wars, and many staff joined up to the armed forces or the war effort during both. As well as a number of other women serving in London, a Lieutenant Yates featured in press coverage at the time of the First World War. She signed up to serve in the Women's Reserve Ambulance Corps as a driver, and was deployed to the Dardanelles. By 1919, 93 former members of staff had lost their lives in the conflict, and were commemorated on a war memorial that still remains on the north façade of Blythe House.

War also brought change for the Bank's customers: it gave the government the opportunity to frame saving for the future as not just sensible, but as a patriotic duty. From 1914 to 1920 there was significant growth in savings, based in no small part on War Savings Certificates (which later became National Savings Certificates). These continued to be sold until after the Second World War, and established the reputation of the Post Office Savings Bank as a trusted institution for savers all over the country.

The Second World War brought the violence of conflict to Blythe House itself. The bombing of London during the Blitz caused significant damage to surrounding Hammersmith and Chelsea, being hit particularly hard by incendiary bombs and regularly costing Blythe House its window panes. In the late 1930s the basements were reinforced to provide air-raid shelters for the staff. Many of the POSB's former employees interviewed for this book spoke of air raids and the impact of war while at work in the Bank, including their relief when bombing finally ended.

[VE day] was such a relief, you know. OK, we hadn't had bombs for a long time, but it was just the relief that we'd never have another one. So, looking back on those days, we were all cold, it was dark, gloomy and we were all hungry. I mean, we were growing girls and we were always hungry [laughs]. But there we are, we survived.
– June Fenwick

The Second World War memorial for the staff of Blythe House 'who in the services or as civilians gave their lives' was unveiled in 1953, and later moved to Glasgow when the Bank ceased operations in London.

In 1969 the Post Office Savings Bank became National Savings & Investments, a separate government department and no longer linked to the Post Office. And with that, it began its move to Glasgow.

Placards used in the 2019 Science Museum strikes by Prospect Union members at Blythe House, continuing Blythe's long history of trade union action.

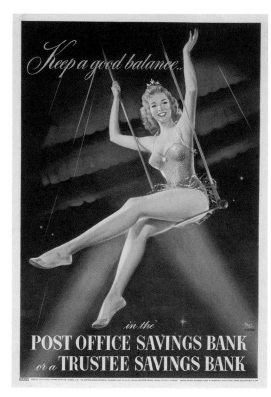

'Keep a good balance', Post Office Savings Bank poster c.1945.

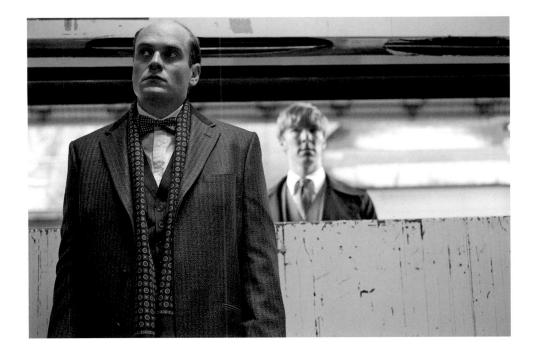

Blythe House had an uncertain future at this point, as an enormous institutional building that had been so carefully designed for its original purpose. During this period, it was leased to the Hammersmith-based Euston Films, a subsidiary of Thames Television. This was the beginning of an exciting new life for Blythe as a film location, a life that continued for more than 40 years, even after Thames departed. Completely anonymous in time and space but also distinctive and instantly recognisable to those who know its expressionless corridors well, Blythe House has had quite the Hollywood career.

Although Blythe House has led a relatively secluded life, even if you have never visited it is quite likely you have seen it before. It has played key roles in film and television shows since the late 1970s. The building is so imposing and its interior so unusual that it stands out, even as a neutral backdrop. Its anonymous corridors make the perfect institutional scenery, and it has many times stood in for hospitals, including in *Before I Go to Sleep* (2014), *The Danish Girl* (2015) and *Blithe Spirit* (2020). It featured as an orphanage in *Pan* (2015), a police station in *Thor: The Dark World* (2013) and a safe house in *The Hitman's Bodyguard* (2017). It was a Russian government ministry in *The Death of Stalin* (2017) and the Labour Party headquarters in *The Crown* (2016).

Toby Esterhase (David Dencik) stands inside the Blythe House goods lift as the vertical doors behind him open to reveal Peter Guillam (Benedict Cumberbatch) in *Tinker Tailor Soldier Spy* (2011). Credit: Jack English

> We often experienced Hollywood glamour in the stores! I showed Dame Helen Mirren and Ryan Reynolds the Vivien Leigh archive. They were making *Woman in Gold* [2015] and used our stores extensively for the filming. Ryan Reynolds was charming and so interested in the Hollywood material.
> — Keith Lodwick

It has also featured heavily in spy dramas. One of its earliest productions (along with *The Sweeney*, 1974, and *Minder*, 1979, both by Euston Films) was *The New Avengers* (1976), followed by *Allied* (2016) and *Tinker Tailor Soldier Spy* (2011). In the latter – an adaptation of John le Carré's 1974 spy novel about uncovering a double agent high up in MI6 – Blythe House takes on the role of 'The Circus', the code name for the Secret Intelligence Service's headquarters. Even the real headquarters of MI6 looks less like a secret HQ than Blythe House does.

> Blythe, despite the impossibility of actually accessing the collections I was funded to research and see, was truly glorious. It was a weird timeless haven of objects and research and secrets. It felt more like the *Tinker Tailor Soldier Spy* film's rendition of it than anything else: people milling around, knowing special information, and using rooms that you had no idea about, and discussing things you didn't understand. I loved it.
> — Lauren Fried

The last film to be made at Blythe House, before the museum decant programme made the disruption of filming too difficult to bear, was *The Father* (2020) starring Olivia Colman and Anthony Hopkins (who won an Oscar for his role). Blythe was

used as the exterior of a nursing home, with Colman seen departing. At the time of filming, Colman had not long won an Oscar of her own for her part in *The Favourite* (2018), but went unrecognised when she arrived at Blythe's gates, and was given a neon security wristband and made to sign in to the building.

After the lease to Euston Films ended, the British government acquired Blythe House from National Savings & Investments for the purpose of museum storage, at a cost of £6.5 million in 1979. The Victoria and Albert Museum (V&A) was the first to

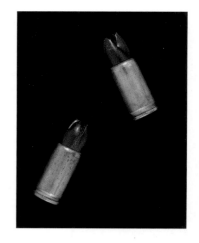

Spent bullet casings left on the roof of Blythe House following the filming of *American Assassin* (2017).

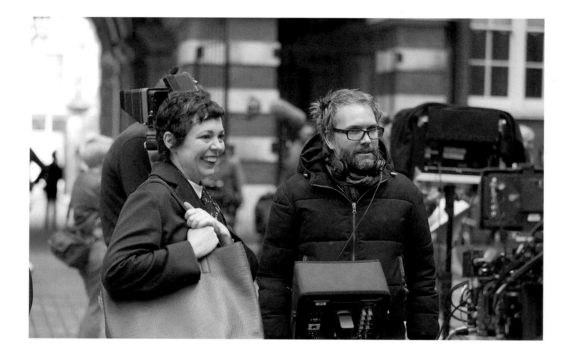

Actress Olivia Colman and director Florian Zeller on the set of *The Father* (2020) at Blythe House, in the central courtyard. Credit: Sean Gleason

move into spaces in the basement and ground floor in 1983, followed by the Science Museum and the British Museum over the next several years.

Before moving in, the Science Museum had previously had stores at Hayes in Middlesex, where its collections were kept in a warehouse. Also in the late 1970s, an airfield in Wiltshire was acquired, the former RAF Wroughton, which became a store for the largest Science Museum objects in 11 disused aircraft hangars.

The first of its collections to move into Blythe House was not technically a Science Museum collection – it was the medical history collection amassed by Sir Henry Wellcome, a pharmaceutical entrepreneur and the co-founder of Burroughs, Wellcome & Company. Wellcome was a prolific collector, particularly of objects related to health and medicine, in the very broadest sense. When Henry Wellcome died in 1936, a charitable foundation was established from his vast fortune to fund medical research, the Wellcome Trust. Part

Olivia Colman's signature on the security sign-in sheet for her day of filming *The Father* (2020).

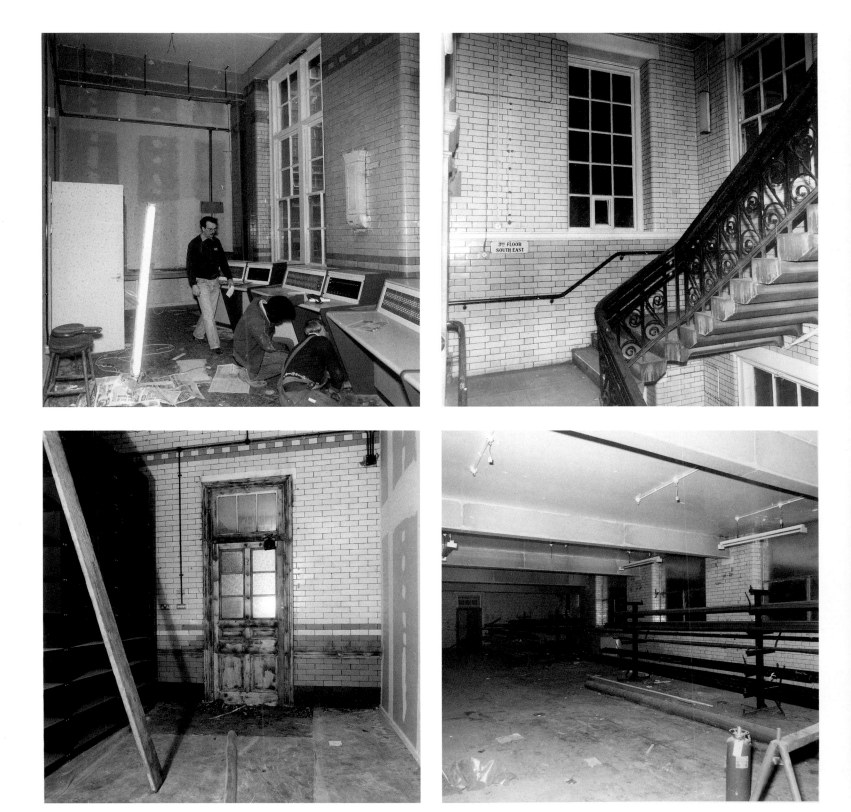

Blythe House in the early 1980s,
ahead of the museums' move in.
Credit: Department of the Environment

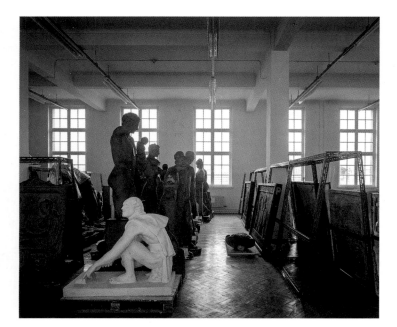

British Museum sculpture casts (Room F1).

V&A furniture collections (Room FF15).

of the Wellcome Trust is the Wellcome Collection, a museum on Euston Road in which a small section of the medical history collection is showcased in a changing series of galleries and exhibitions. But the collection itself is in no way small: it accounted for approximately 110,000 objects of the *c.*300,000 objects in the Science Museum's care at Blythe House. It took up most of the Science Museum basement and ground-floor portion of Blythe, and included surgical instruments, medicine chests, early X-ray machines, medicines, wax anatomical models and veterinary tools.

The Science Museum housed a vast amount of its own collections at Blythe House, too, including those relating to art, physics, chemistry, domestic appliances, aeronautics, space technology and computing. Blythe also held a large conservation laboratory and a photography studio. Objects ranged from the tiny to the huge, from a few grains of sand fused together by the first atomic bomb test in New Mexico, to a 19-metre-long rowing boat, which won the Boat Race for Cambridge University in 1934.

The V&A housed its Theatre and Performance collection at Blythe House, as well as furniture, clocks, ceramics, significant archive collections and photography, and a number of conservation laboratories. Prior to this, much of the V&A's collection was stored in South Kensington, where its museum building takes up around 12 acres. There were also smaller stores at Gee Street near the Barbican, in the basement of LaFone House near London Bridge, and at Neil House in Whitechapel, along with a warehouse in Battersea. The move into Blythe House allowed the consolidation of some of these collections in one place, including William Morris's hand-drawn designs for wallpaper, textiles, furniture and tiles, and comedian Tommy Cooper's personal archive of documents, posters and famous props. The V&A's archive at Blythe was also the setting for Artangel's exhibition *The Concise Dictionary of Dress* in 2010.

In 2013 the V&A opened the Clothworkers' Centre for the Study and Conservation of Textiles and Fashion. This was the most explicit invitation to the public to come and visit the collections at Blythe House, providing a dedicated public study room for the textile collections, from archaeological fragments and elaborate carpets to couture designs by Alexander McQueen, Vivienne Westwood and more.

In common with the V&A, the British Museum's main site in Bloomsbury is large, and much of its collections were (and are) stored on-site there. Since the 1970s, the

museum has also held material in Franks House in Hackney, which is currently home to UK materials from the Palaeolithic through to Roman Britain.

The British Museum collections at Blythe House were largely made up of plaster casts and archaeological material, including the Vindolanda tablets, some of the earliest known handwritten documents ever found in Britain. Like the V&A, the British Museum also held much of its textiles collection at Blythe House, although smaller and quite different, including feathered cloaks, ancient Egyptian burial shrouds and fragments of early Byzantine patterned fabrics. Perhaps the most prominent object the British Museum held at Blythe House, however, was not actually *inside* Blythe. It was the Igor Mitoraj sculpture *Tsuki-No-Hikari* (1991), which features on the cover of this book. After a period on display outside the British Museum, it was placed in the central courtyard at Blythe, where it gazed silently out of the gates towards Blythe Road.

Despite this long and colourful history of the treasures of three national museums all coexisting in one space, Blythe House was not an ideal museum store. It is humid in places and too dry in others; temperatures vary wildly, particularly in the cold basements and the unbearably hot fourth floor in the sun. Volatile conditions like these can damage fragile objects in museum care, which need stable, predictable conditions to prolong their existence. A small army of conservators battled these conditions for decades, and many improvements were made, but with unstable environments in a rented building, there were only so many adaptations that could be implemented.

The rooms range from being large enough to hold 200 people, to so small that barely one person can work there comfortably. There have been leaks, both from plumbing and flat roofs, and at one point an explosion of soot from a disused chimney, which meant an entire collection of chemistry objects needed to be cleaned. Every corner of these rooms was adapted as best it could be, but none of them was ever purpose-built to care for museum collections. However, Blythe House sits at the edge of the London Borough of Hammersmith and Fulham, and only one street over from the Royal Borough of Kensington and Chelsea: as of 2023, the two richest boroughs in the UK. Although it is not a perfect museum store, it is certainly a very valuable building.

Science Museum prosthetics store (Room G37B). Much of the Science Museum's medical collections expand and build on the Wellcome Collection, which the Science Museum now looks after.

It was perhaps for these reasons that the decision to leave Blythe House did not come as a surprise to most working with the collections there. In 2015 the Conservative government issued the traditional autumn statement, which sealed the fate of Blythe as a museum store:

> The government will also provide £150 million funding support to the British Museum, Science Museum, and Victoria and Albert Museum to replace out-of-date museum storage, including at Blythe House, with new world-class facilities to preserve and protect over 2 million fragile and sensitive objects. Blythe House will be sold in due course.[9]

Although a joint solution was initially explored, the three museums are departing Blythe House and all going their own way. The collections of the V&A and the Clothworkers' Centre will be relocating to the Queen Elizabeth Olympic Park in

Stratford, where the brand-new V&A East Storehouse will contain the former contents of their parts of Blythe House. The British Museum is moving some of its collections to Reading, where it will open the British Museum Archaeological Research Collection in Shinfield, while moving other objects to the World Conservation and Exhibitions Centre in Bloomsbury, adjoining the museum itself. The collections of the Science Museum are moving to Wiltshire. The former RAF Wroughton, purchased first for the storage of extra-large objects, is now the site of the National Collections Centre. A new state-of-the-art storage facility has been built to accommodate all the objects that have been moved out of Blythe House, and many more from the old aircraft hangars at the airfield, which are (like Blythe) magnificent historic buildings in their own right, but do not provide ideal museum storage.

As part of the Science Museum's work to vacate Blythe House, it was decided that there needed to be something to mark the departure of the three national museums. Together, the museums are cataloguing, photographing and relocating well over a million objects. It is possibly the biggest change in UK museum history since the Great Exhibition of 1851. But, although much good work has been done to better understand and document the collections that used to be housed there, museum storage is likely to have been Blythe House's last public life before it is redeveloped again for a new purpose, which brings us to this book.

Memory Bank was born out of the near-universal affection felt for Blythe House by the people who worked there. We have gathered interviews and written recollections ranging from the 1930s to the 2020s, and from people who were a part of all aspects of Blythe House's history, from bank to film set to research hub to store. We have dug into the archives to find traces of Blythe's past that are now beyond living memory, to capture something of its early days. And we have photographed the building and its inhabitants using a large-format Sinar P2 camera, which was once used to take photographs of the Science Museum collections in the photo studio at Blythe House, but as time passed, itself became a relic of a different age worthy of a place in the stores.

Blythe House has seen 124 years of history play out inside (and just beyond) its walls. As a piece of architecture it is an amazing testament to its innovative construction and Tanner's ambitious design. As a bank it transformed forever the economics of savings for ordinary British people. As a film location it has probably been seen by more people globally than many royal palaces. And as a museum store it is where hundreds of museum workers learnt their trade, and it has shaped and grown the collections of three of the largest museums in the world.

We do not know what Blythe House's next life will be, but the several extraordinary lives it has had so far deserve to be celebrated.

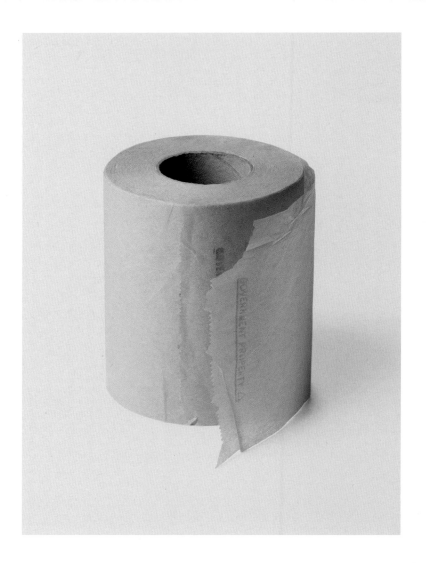

Government-issue toilet roll found at Blythe House, of unknown age.

1 Cusack, Patricia, 'Architects and the reinforced concrete specialist in Britain 1905–8', *Architectural History*, vol. 29 (1986), pp. 183–96, p. 185.
2 'The new Post Office Savings Bank', *The Graphic* (15 August 1903), p. 10.
3 Crowley, Mark, 'Saving for the nation', in Erika Rappaport, Sandra Trudgen Dawson and Mark J. Crowley (eds), *Consumer Behaviours: Identity, Politics, and Pleasure in Twentieth-century Britain* (London, 2015), p. 201.
4 Campbell-Kelly, Martin, 'Data processing and technological change: the Post Office Savings Bank, 1861–1930', *Technology and Culture*, vol. 39, no. 1 (1998), p. 17.
5 Ibid.
6 'Lady clerks in the Post Office Savings Bank', *Aberdeen Press and Journal* (Friday 22 November 1907), p. 5.
7 Ibid.
8 'Super-man', *Dundee Evening Telegraph* (26 December 1907), p. 3.
9 '8.2: English Devolution', in HM Treasury, *Spending Review and Autumn Statement 2015* (London, 2015).

First Encounters

Blythe House is a mysterious building. Huge and ornate and designed to be imposing, but with no clear function or external announcement of its purpose. This seems to have been the case while it was the Post Office Savings Bank, although the employment of thousands of people in West London is likely to have lessened its anonymity in its early days. As a museum store, however, there has historically been very little indication outside of the building of the treasures within.

This was partly for security, as that is always a paramount concern of museum storage sites. Most of Blythe's museum workers even had completely blank ID badges to let them in through their own specific set of doors and turnstiles. Without ever announcing it to passers-by, Blythe House was probably one of the most secure buildings in West London when it held museum collections, quite possibly more secure than when it was a bank.

This deliberate anonymity has made a mark on how people have experienced the building. A recurrent theme of nearly all the interviews and stories for this project has been a vivid recollection of people's first encounter with Blythe House, and the intimidation that most of them felt. This was the point at which people were unsure of which entrance to go to, or how they would ever find their way out.

Folkloric tales of wayfinding, however, also came out strongly. As time passed, people developed an intense familiarity with their particular corner of the building, finding their way through habit, sound and smell as much as by sight, for the anonymity continued inside the long, identical corridors and obscure, unlabelled doors. But the tales of first, disorientating encounters remain striking. So, we started by asking everyone the same question: do you remember your first day at Blythe House?

Coming from a small town, Musselburgh, on the outskirts of Edinburgh, and never having been outside Scotland, my journey to London was a major event in my life. I was not yet 18 years old, fresh from school and quite immature. Accommodation had been arranged for me at a hostel in Ovington Gardens, Knightsbridge, which provided dinner, bed and breakfast Monday to Friday and full board at weekends for people like me who were working in the Civil Service away from home.

— Alex McDonald

I have to confess, I was just thinking about it. I used to find it quite an intimidating place to go, because I was a young, early 20-something, moved down from Aberdeen. I wasn't very, sort of, worldly wise. I wasn't very aware of what architecture and the building was about. And I mean, Blythe House is vast and complicated, and the way it's divided up by museums isn't particularly helpful in terms of navigating your way around. So, in those days, hardly anybody ever used to go to work there.

— Karen Livingstone

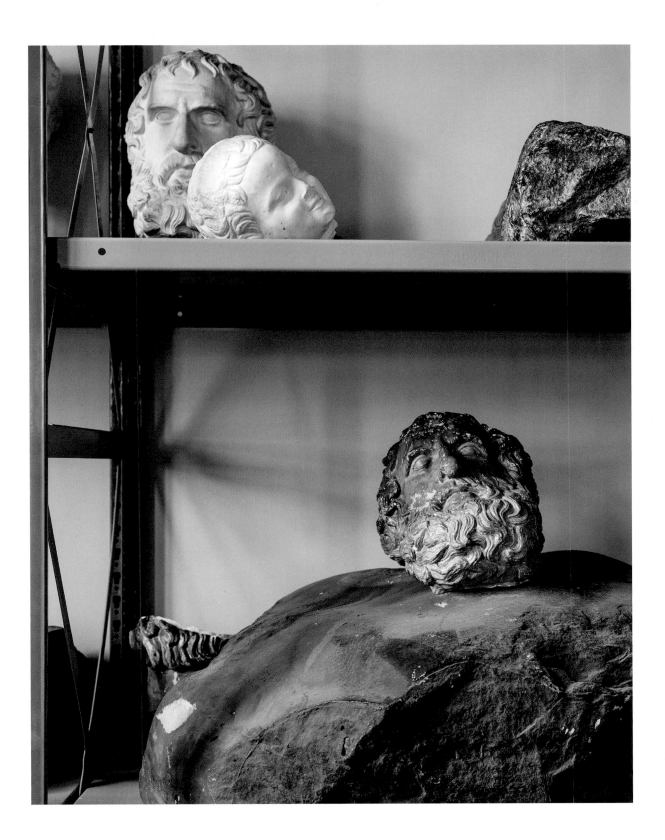

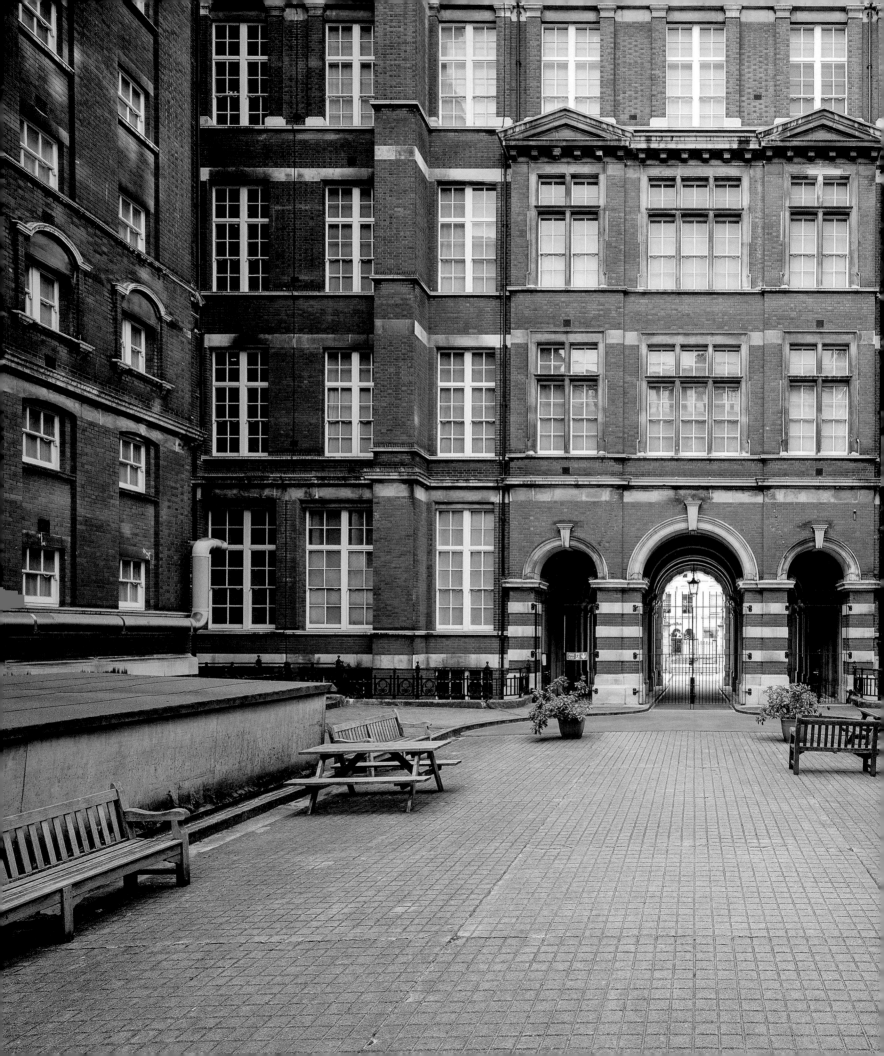

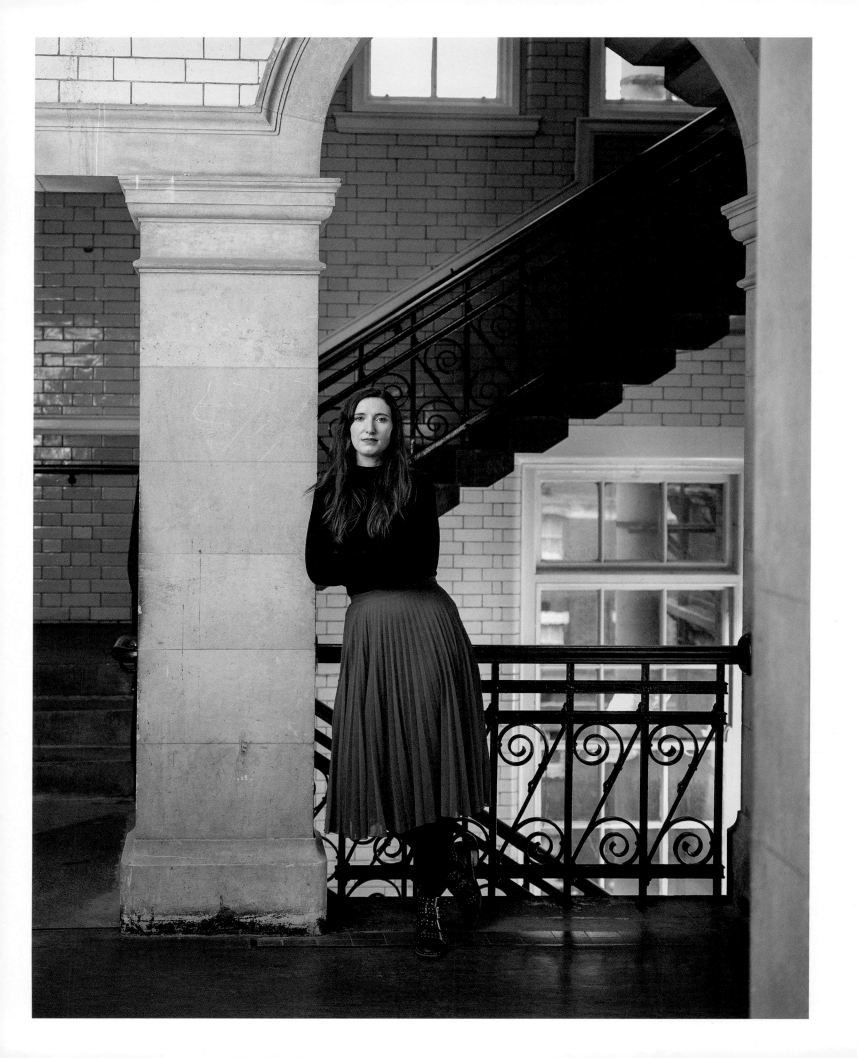

I left school at 14, and having no idea as to what I wanted to do, my father took me to the local Youth Employment Bureau. I was given a test and told that the Post Office had a vacancy for a Boy Messenger at the Post Office Savings Bank. Although it was 11 miles from home, in those days it was a job for life. I started there on 20 September 1943 and by 10am I was encouraged to join the Union of Postal Workers. My first week's pay was 14 shillings.

— Dennis Creasy

I remember coming to the site with a senior colleague, Geoff Voller, not long after the building had been acquired. By that time I'd been a Museum Assistant for a very long time. This would have been about 1982 or so but I'd have to check my diaries. And it was completely unconverted. It was a rather large dusty, dreary-looking building and my one sense, as Geoff and I walked round the building, was this is a major challenge to make this into a museum store.

— John Liffen

My main memories of the first time I visited
were bewilderment of how to get in. I had
cycled from Bloomsbury and found an array
of different entrances not all of which were
accessible with a bike. I followed a few
people to try to work out my way in, and
it did feel like you were entering a space
known by these few regulars who you relied
upon for all the inside information.

— Shelley Angelie Saggar

I was very intimidated. I found the building
overwhelming, cold and a bit bleak (it was
January 2007, so the weather probably didn't
help!). Someone described it to me as Colditz!
It felt very institutional. Working in that
area of London was also a shock as I had
previously worked in Covent Garden. Suddenly
I felt like I was working in no-man's-land.

— Keith Lodwick

I actually remember my first day so clearly:
firstly, being scared of being trapped in the
rotating doors as I came through the side
entrance but also about the people I would
meet and the work I would be doing. I'd
volunteered in collections stores before,
but Blythe House is something else entirely:
such a grand and impressive building and
knowing I'd be working with such exciting
collections and alongside people from the
British Museum and the V&A.

— Terri Dendy

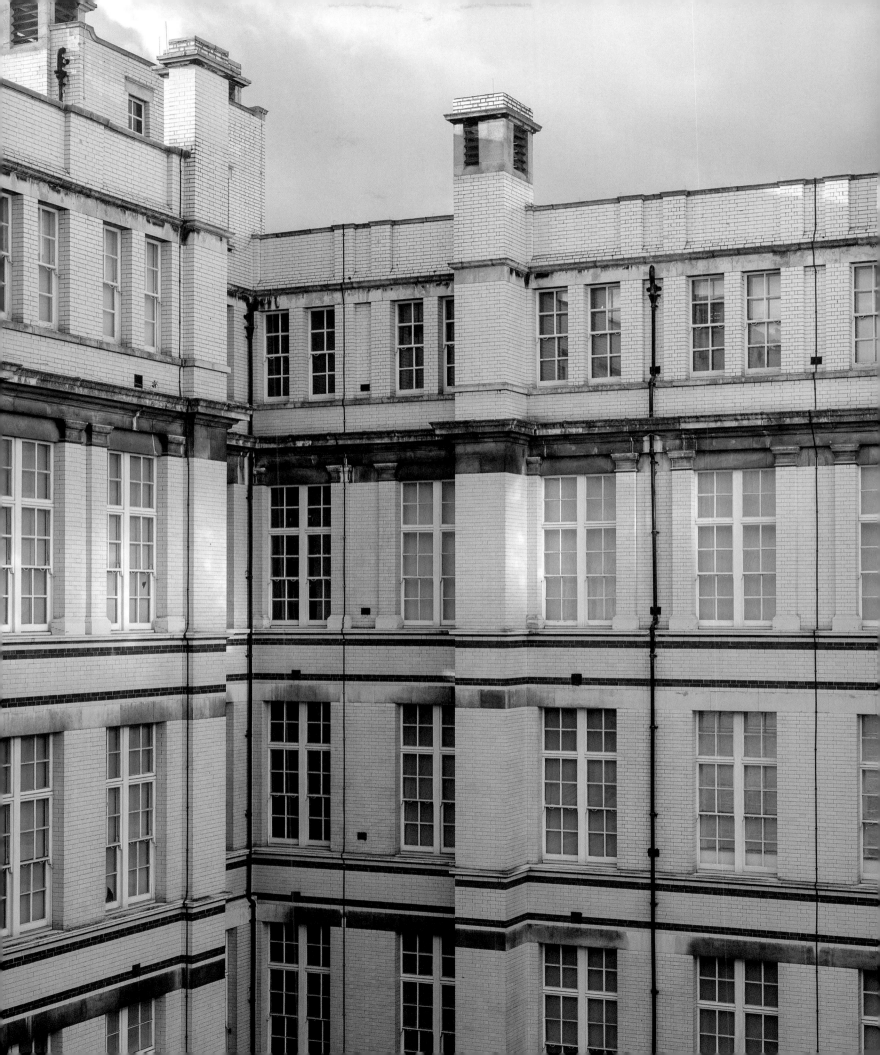

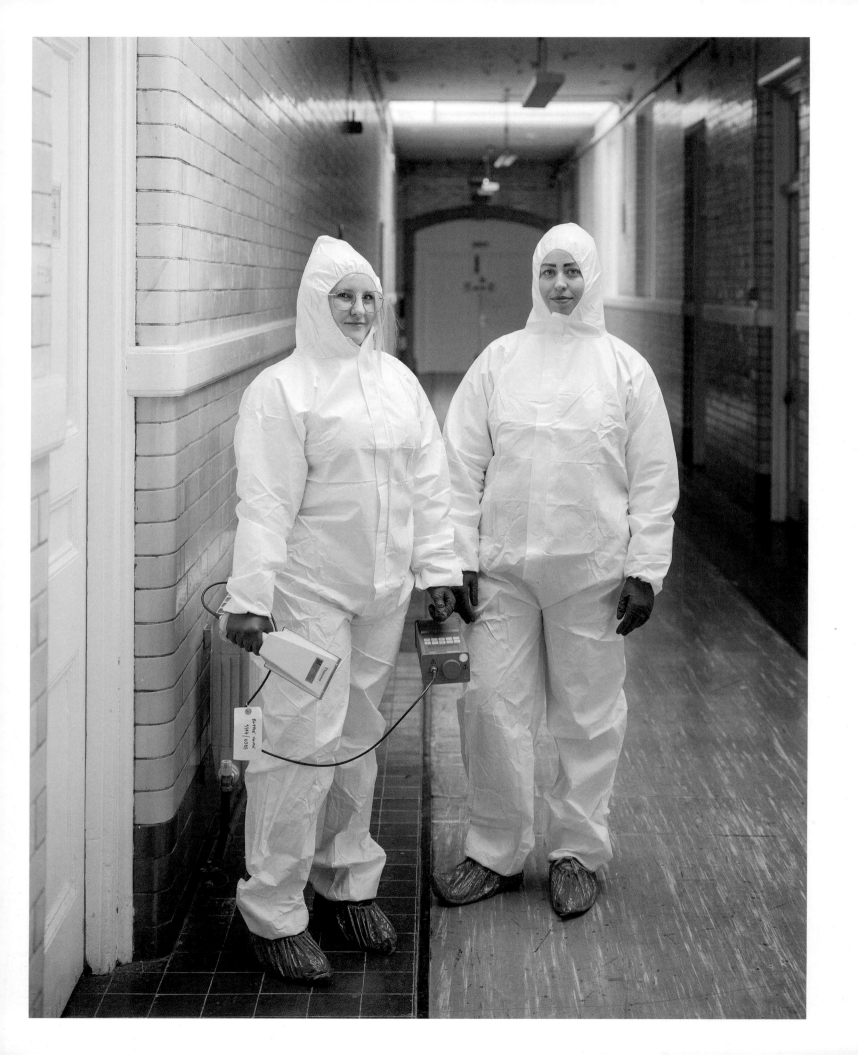

My first day at Blythe House was in our training branch, where we received a week's training. After our week in our training branch, we came onto our departments and from there on in we had a tutor. Until we were confident enough to carry on on our own, we had somebody sit with us.

— Maureen Mulvanny

It seemed labyrinthine and rather grim. I was shown round by Ray Waters, the Senior Museum Assistant in the Department of Prehistory and Early Europe at the British Museum (BM). We occupied the basement and ground floors. At that time the various departments of the BM were very separate from each other, and I rarely went to the other floors in the first five years of my time there: I don't think I had the clearance to sign out the keys for them in any case. So, they were shadowy, unknown areas that I had only a very vague idea about. The rest of the building, populated by the V&A and Science Museum, was completely unknown to me.

— Lucinda Smith

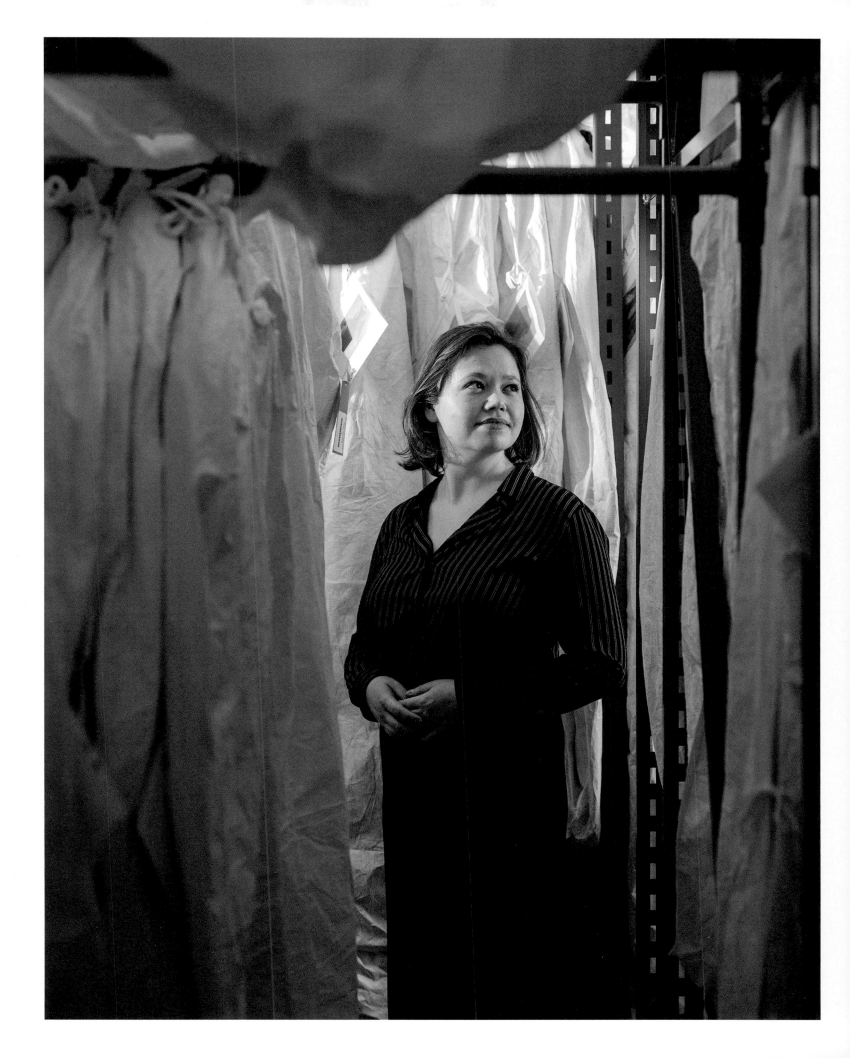

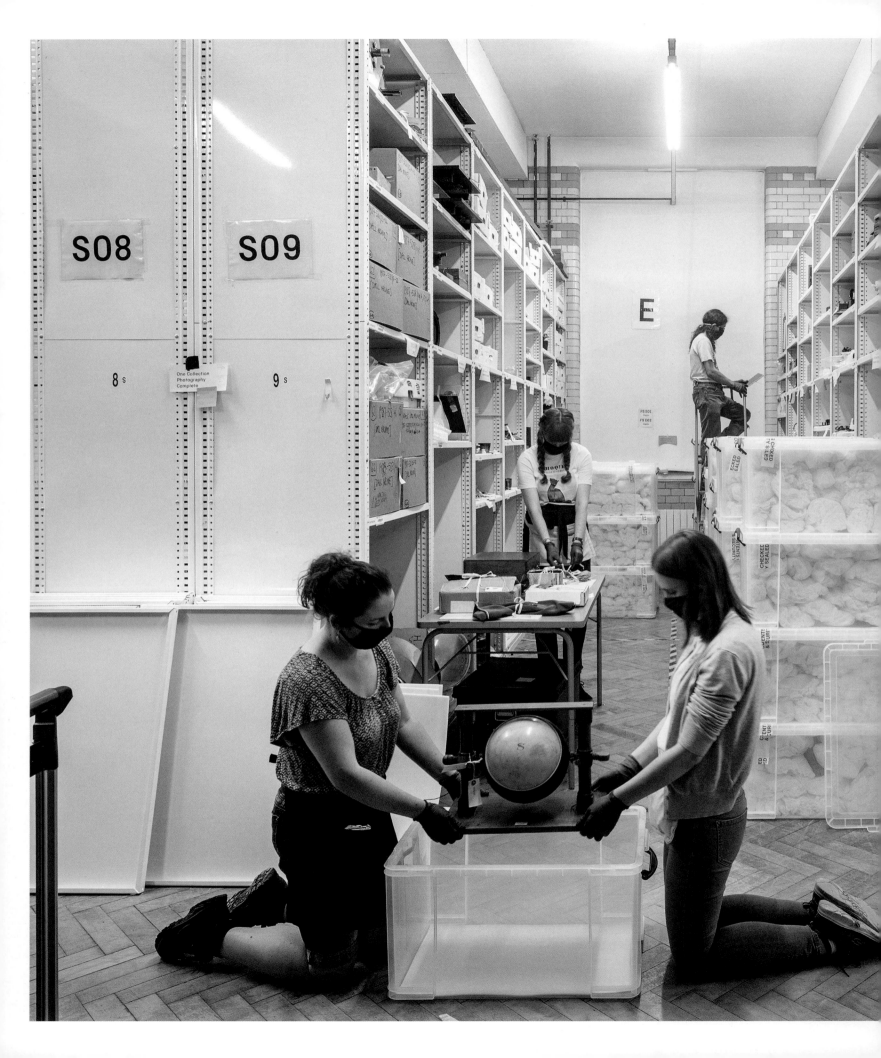

You know, I'd come from school. It was different; had to learn new techniques and things like that. Because when I came here, one thing I had never done … was use a telephone. I know it sounds weird now, doesn't it? But we didn't have one at home. And I'd never had to answer a telephone.

— June Fenwick

I think it was one of my first days of filming at Blythe House and actually it wasn't a TV drama or feature film. It was for a documentary, filming in one of the external stores. … It was looking at our Asian collection and I just remember somebody pulling out a drawer of poisonous arrows. You weren't even allowed to touch them with gloves on, because the poison on the arrows was still sort of lethal, and there were skull and crossbone signs all over the drawers and that really, really stuck in my mind.

— Rachel Lloyd

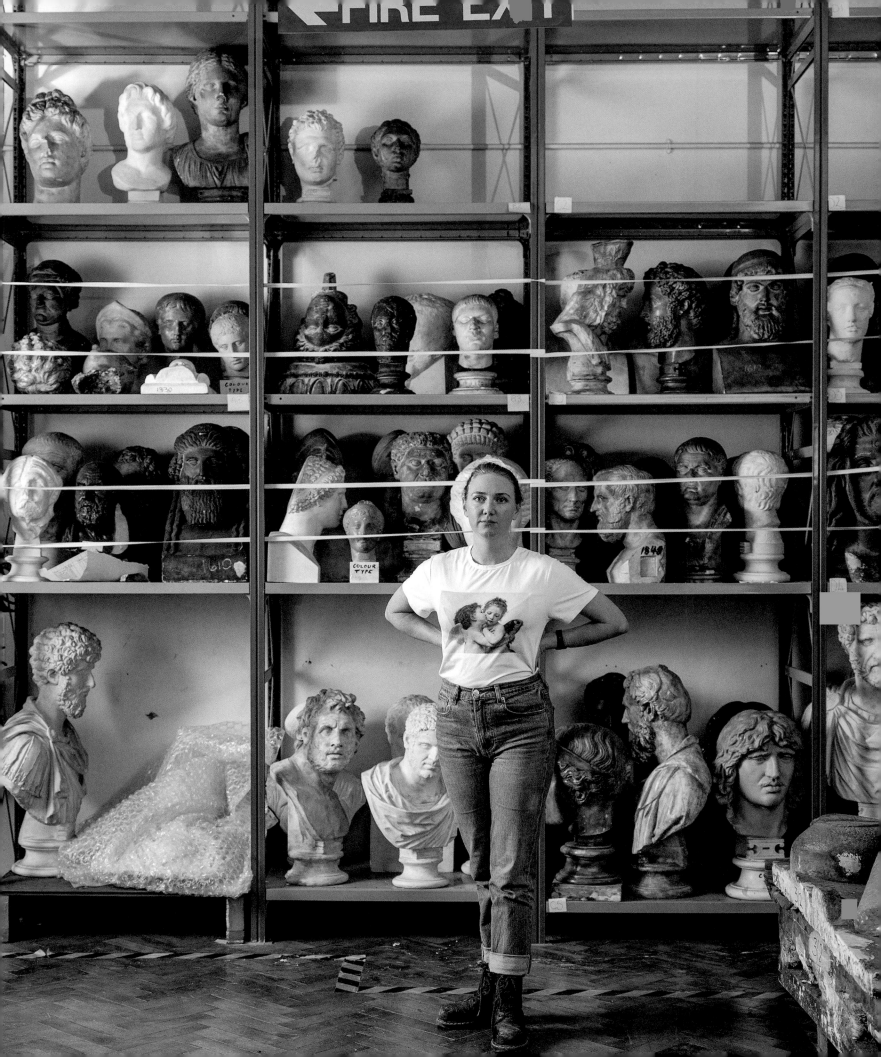

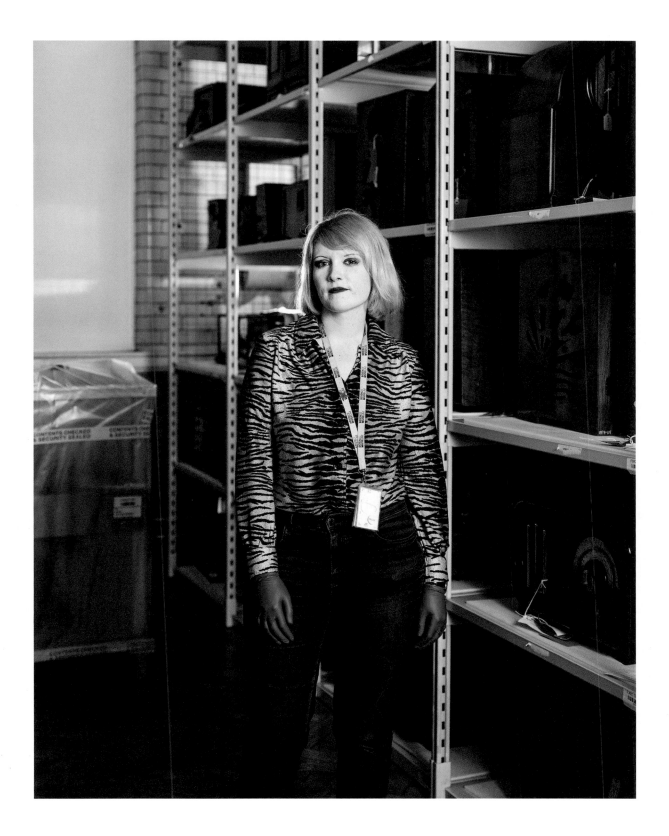

My first visit to Blythe House was with
Dr Bracegirdle, Curator in Charge of the
transfer of the Wellcome collections to
the Science Museum, in order to survey the
basement area as a possible storage site
for Wellcome material. … The building had
been neglected for over a decade and the
basement in particular had suffered greatly
as a result. Dr Bracegirdle was quite
enthusiastic and optimistic but I, knowing
it would be partly my responsibility to
transform this chaos into some form of
acceptable storage facility, was somewhat
daunted by the challenge.

— Peter Scott

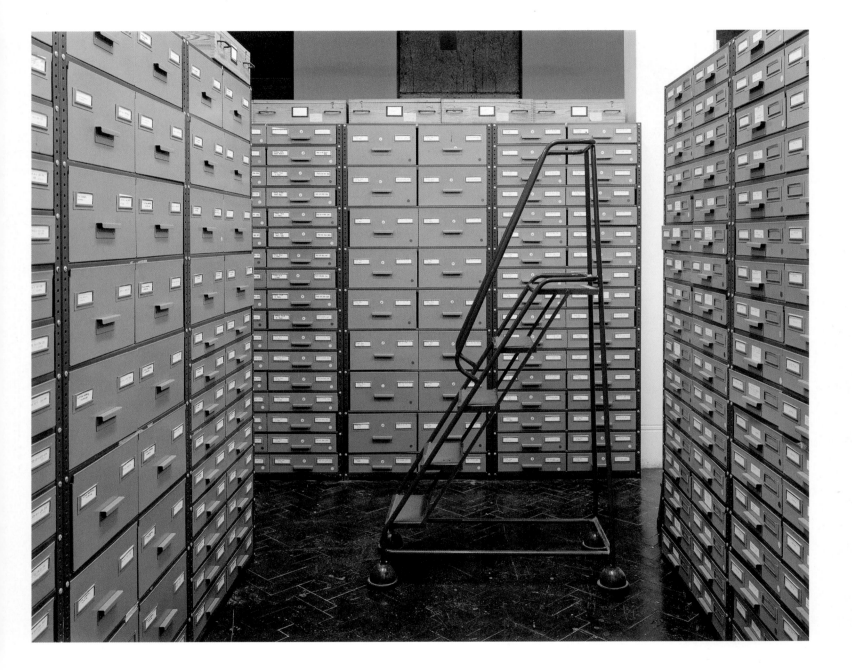

I can no longer remember my first visit to
Blythe House. I know it took me a while not
to feel intimidated by the turnstile at the
staff entrance and several months to come
under the building's unique spell as I
wrestled with the magnitude of the project.

— Edwina Ehrman

When I first arrived as a volunteer I went to
the wrong entrance (Gate B) where I spoke to
an unimpressed member of security staff via
the wrong intercom! Every day entering Blythe
is like the first day though, the excitement
of the beautiful building and the never-ending
surprises within have never gotten old.

— Kerry Grist

I do recall my first visit in late 1985;
I had just transferred to the Wellcome
Department after three years in the lecture
service, where I was also a Museum Assistant.
The first parts of the Wellcome collection
(microscopes) were already at Blythe House,
and Sandra Bicknell (another Museum Assistant,
later Head of Audience Research) was leading
on unpacking. We had the whole unpacking of
the collection (coming from Hayes and Wellcome
on the Euston Road) ahead of us, although
we awaited the construction of a ramp to
the basement for the big things to come in.
In your early career everything is strange:
Blythe House was certainly no exception!

— Tim Boon

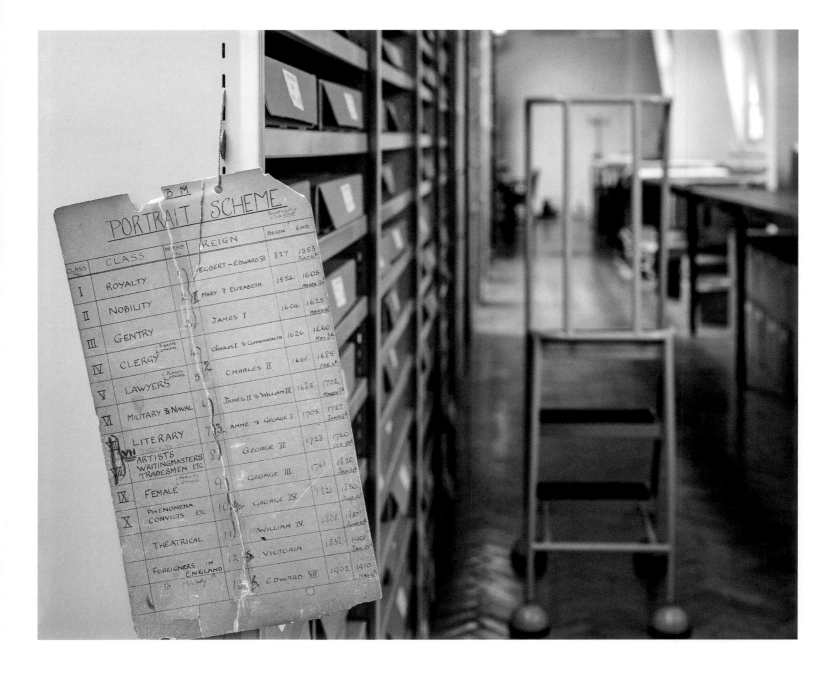

The Building

The architecture of Blythe House is visually striking. This was a building on which little expense was spared, and which was considered a modern and significant enterprise. As well as its ornate façade and grand design that allowed room for future expansion, Blythe House was an early site of reinforced concrete, a material of which the building's architect Sir Henry Tanner was an early pioneer. An opulent, bespoke clock made by William Potts & Sons of Leeds was installed, facing out towards Shepherd's Bush above the main entrance.

It took four years to complete the building, and there were a number of staff facilities, including several subsidised restaurants and an on-site medical ward. The Post Office Savings Bank was a significant early employer of women, although the men and women who worked there were segregated until 1936. A separate ladies' entrance was constructed, part of which is now known as the 'Chicken Run', a flimsy exterior wooden corridor that became the main entrance to the Science Museum stores.

The eastern extension, constructed in the early 1920s, was largely the domain of the British Museum collections from the 1980s, with the Science Museum and the V&A occupying most of the original building's footprint. Smaller outbuildings scattered around the feet of Blythe House include a boiler house, a 45-metre red-brick chimney and various gatehouses. Several workshops were set up where the western extension might have been in the 1940s, in prefabricated, single-storey buildings. As much as it is tightly contained by its central London location, it sprawls where it can into many quirks and features beyond its original monumental block.

The interiors are equally distinctive, having been mostly left intact. The building is four storeys high with a basement and an attic. There are a number of small mezzanine floors (mostly former toilet blocks) running between the north and south staircases in each of the four corners of the main building. The staircases themselves are decorated with iron balustrades, and open with a view all the way up to the top. There is a spiral staircase in one corner, leading up to the roof and its far-reaching views across London.

Particularly unusual, and contributing to the anonymous institutional feel of the building, is the use of glazed wall tiles throughout in cream, soft yellow and pale green, especially in the endless corridors. This was supposedly due to a strike of the Painters and Decorators Guild at the time when the building needed to be fitted out – tilers were called in instead to finish the interiors. There are huge rooms with herringbone parquet flooring in maple wood, and others that are not much bigger than cupboards.

Perhaps the only features that give away Blythe House's banking origins now are the heavy vault doors in the warren-like basements.

I think I would just reinforce that part of
the joy of Blythe House isn't actually the
collection storage, but the quality of the
building, and what used to happen there before
the museums moved in, and the whole history of
it being the Post Office Savings Bank. And the
lovely traces of that activity and the things
that most people don't really encounter, like
the women's corridors and the way it was used
before it was a museum. I feel more nostalgic
for that in a way, than the museum use. And
I feel very nostalgic for the quality of the
materials. The glazed tiles and the ironwork
and just the building itself, I think, is a
treasure, and I really hope that elements of
that are preserved.

— Karen Livingstone

One of my colleagues in the Treasury had
had occasion to come here one day, and came
back to the office and said, 'You were in
the Savings Bank at Blythe Road?', and I
said, 'Yes', and he said, 'All those lavatory
tiles!' My abiding memory of this building is
the tiles. I think Blythe Road, and I think
public lavatory tiles. And I'm sure that's
one reason why the place is so cold.

— June Fenwick

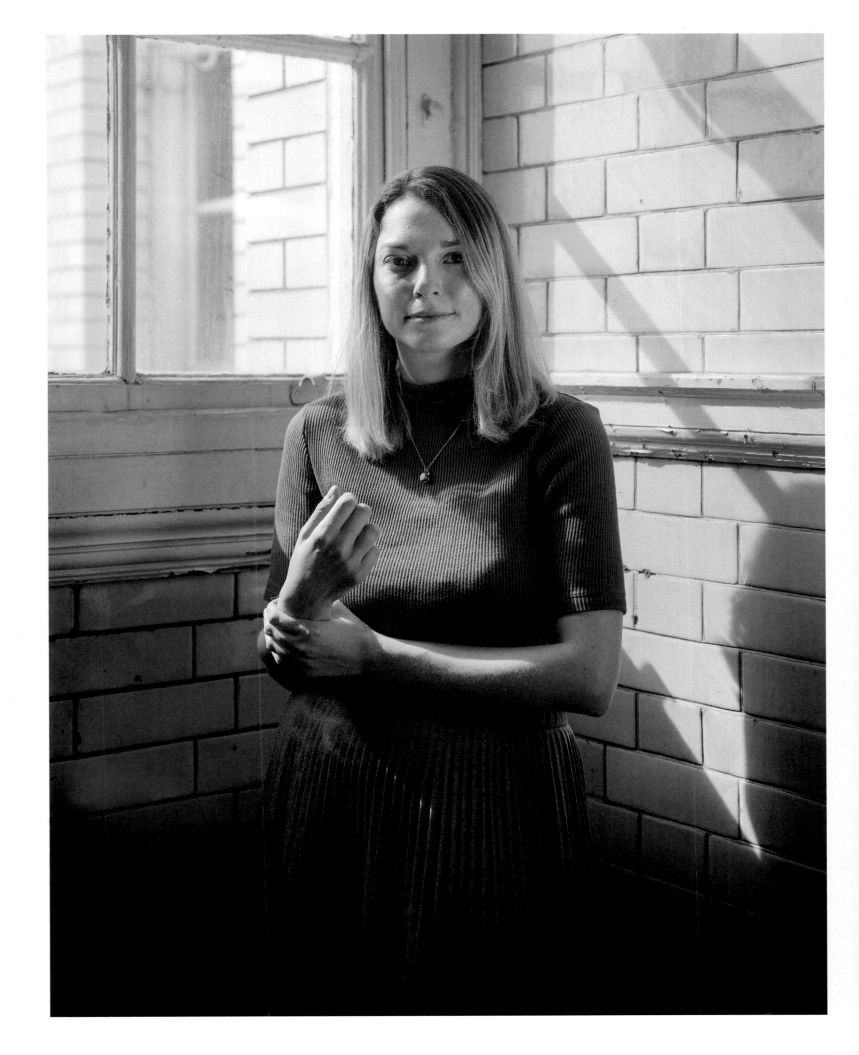

In 1903 William Potts & Sons of Leeds received an order to supply a turret timepiece together with a 6-foot-diameter illuminated dial for the Post Office Savings Bank headquarters in West Kensington, London. The clock was fitted with a 13½-foot-diameter main wheel, gun metal and steel pinions, together with the latest and most accurate escapement and compensated pendulum. The clock is mounted on two cast-iron brackets, each showing the name of the clockmaker, W. Potts & Sons Leeds. Brackets of this type were not always used, but tended to be for more prestigious orders of which this would have been one.

— Michael Potts

Coffee break in the morning and a lunch hour and a coffee/tea break in the afternoon, which was usually spent sunbathing on the roof. No health and safety restrictions. It was odd. There were benches on the roof so we used to go up and sunbathe in our lunch hour.

— Maureen Mulvanny

There's a workshop in Blythe House and we turned that into the set of a textiles factory, so it was a blank canvas. Beautiful faded bricks with peeling paint and dirty skylights. What the art department did was put in a series of sewing machines, big, huge buckets of fabric and stuff like that. So that was the process. Everyone got quite excited. They didn't have to build anything around it, it was kind of a blank canvas for them to bring their vision of what they wanted to do, which made Blythe quite unique.

— Tom Barnes

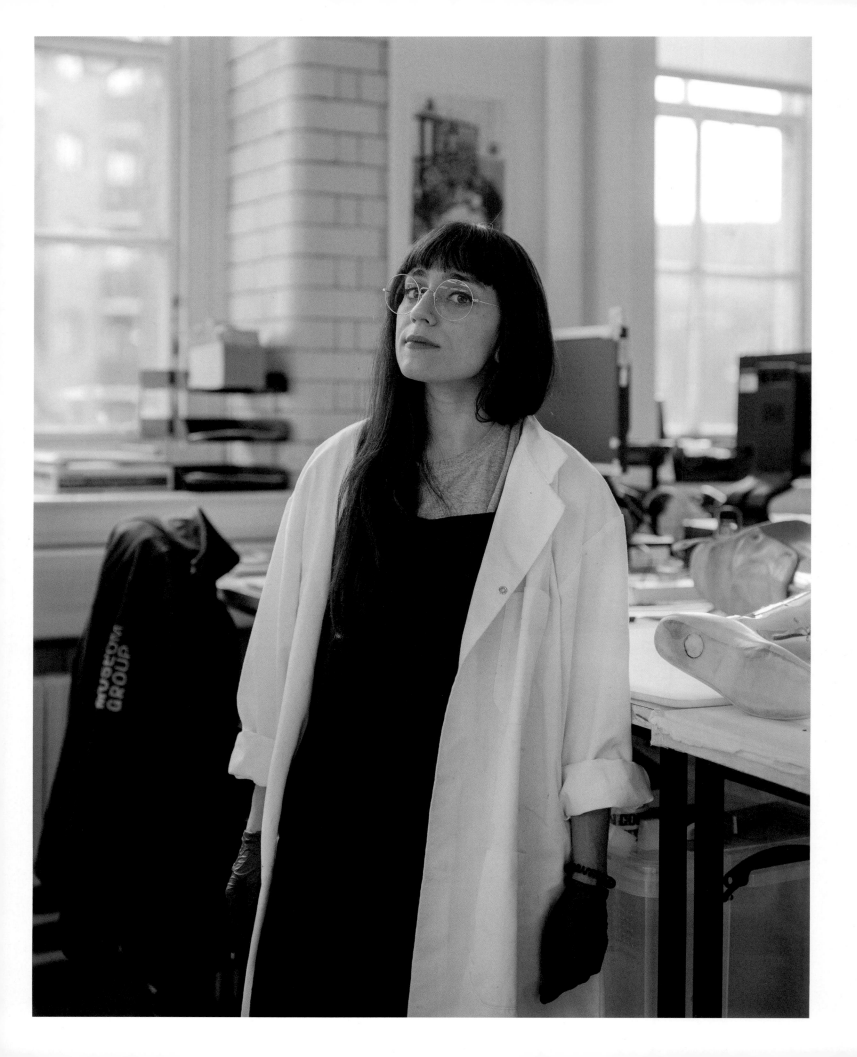

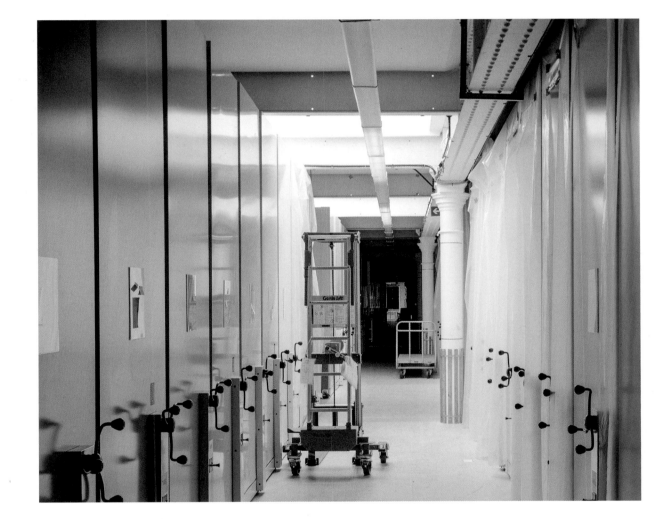

The architecture is functional and slightly
industrial but tempered by glazed brick walls,
and the discerning use of decorative ironwork,
which casts lovely shadows. I particularly
liked the sinuous wrought-iron balustrades
on the stairs and the iron grilles on the
internal windows, which filter light onto the
landings. I also remember the raised studs
on the stair rail, which were quite painful
to encounter by mistake. I was told that the
studs were designed to foil those foolhardy
enough to think of sliding down the banisters:
could this really be true? It conjured up
visions of long-dead post office workers
competing to beat each other's best time
as they shot from floor to floor.

— Edwina Ehrman

The main thing I remember about the building
was that the structure reflected its former
use as a post office building. It was as though
the collections were just squatting there
sometimes. … I think it was a rite of passage
to be taken up to the roof there. The views
across London were amazing; it was quite a
privilege to have that amazing building.

— Megan Thomas

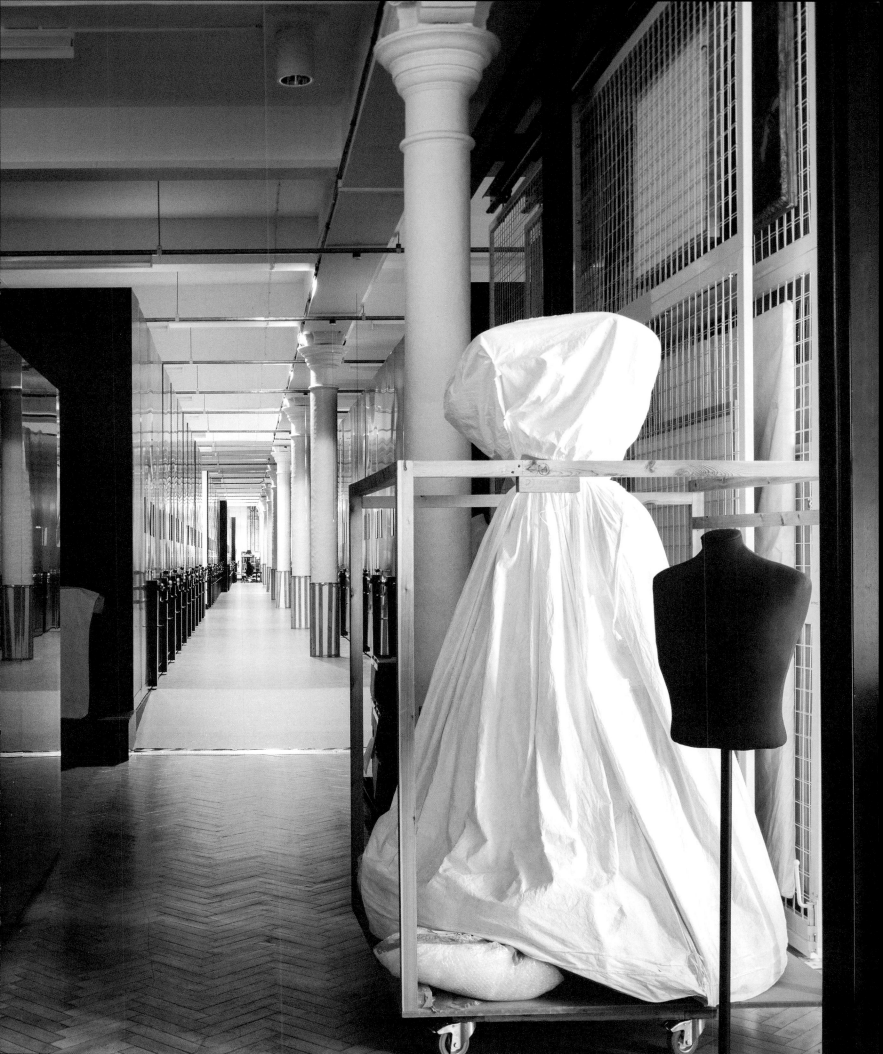

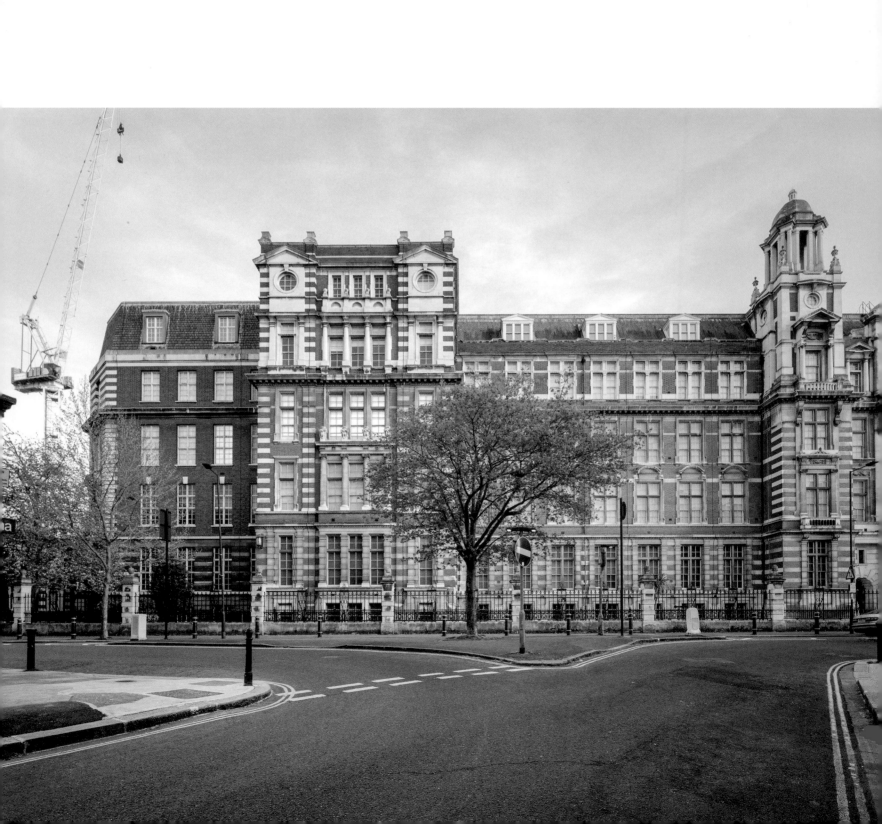

I worked mostly in T26C, a vast room used by several departments, and MG7, MG8 and MG9, which were former toilet blocks. From the point of view of the Science Museum it was good-quality storage. The other museums did not all rate it so highly, but they tended to have more sensitive objects. A problem for the museum was floor loading: it had been an enormously strong building, but the structural engineers were worried about potential corrosion of metal beams in places they could not inspect, and downrated it accordingly. A perverse result of this was that heavy objects such as astronomical telescopes had to be spaced well apart, and so were easy to view.

— Neil Brown

I remember finding the building overwhelming (so tall and so out of place in the surrounding landscape) and thinking I would never find my way around (particularly because of the way the corridors of different sections of the building 'mirror' one another). It was also freezing and I soon learnt to wear extra layers and consider bringing a hot-water bottle to work in the winter.

— Veronica Isaac

I worked in the V&A carpet store in the 1990s before it was refurbished. It was a vast space with high ceilings and row upon row of rolled carpets stored on rods between the pillars. Although it was full of objects it somehow felt very empty and I used to think of all the people working there in the days when it was the Post Office Savings Bank and the constant noise of work. It felt cathedral-like and reverent.

— Lucy Johnston

Vast, cold, a bit bleak and strangely beautiful. I do have a soft spot for it. It's the 'space that time forgot'. Visitors often remark that it's like something from the 1970s. I guess that's why *Tinker Tailor* worked so well.

— Keith Lodwick

I think in scouting in London, there aren't many of the boring parts left – so the service corridors, the servants' kitchens, the loading entrances – they've all been developed. People keep the fancy ballrooms and the stairs; they're preserved, they're Grade I listed. But all of the kind of bread-and-butter locations, and spaces that people would operate in in Victorian times and in the '40s and '50s … they've all either been demolished or they've been modernised.

– Tom Barnes

I first came to Blythe House for a training session just after I joined the V&A in 2012. It was a drizzly day and as I approached the staff entrance, the grimy back wall of the building loomed large against the grey sky. I fumbled through the turnstile and found my way inside, where my eyes took in the faded, functional surroundings: the flaking paint, the warped lino, the fluorescent tubes emitting their harsh yellow light from the high ceilings. This sea of brown and beige and grey was a world away from the marbled halls of South Kensington, and I fervently hoped that I wouldn't have to come here very often.

– Matthew Abel

I'd say also that at that time I started to become much more aware of the building as a piece of architecture, and the qualities of the rooms and all these different spaces. The floor finishes, you know, the tiles, beautiful ironwork, the different character to the listed toilets and one of the levels which had suits of armour in them. The toilet pans had been removed when the armour was in there, but the partitions couldn't be removed because they formed part of the listing.

– Karen Livingstone

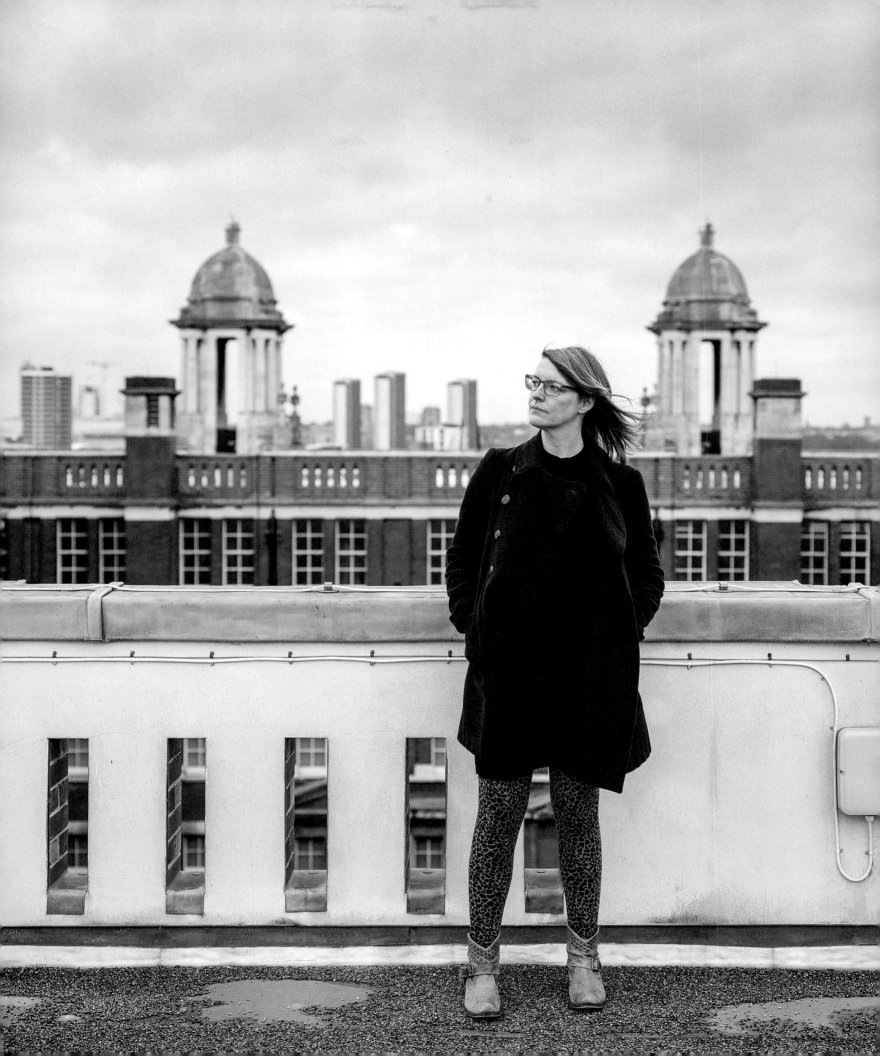

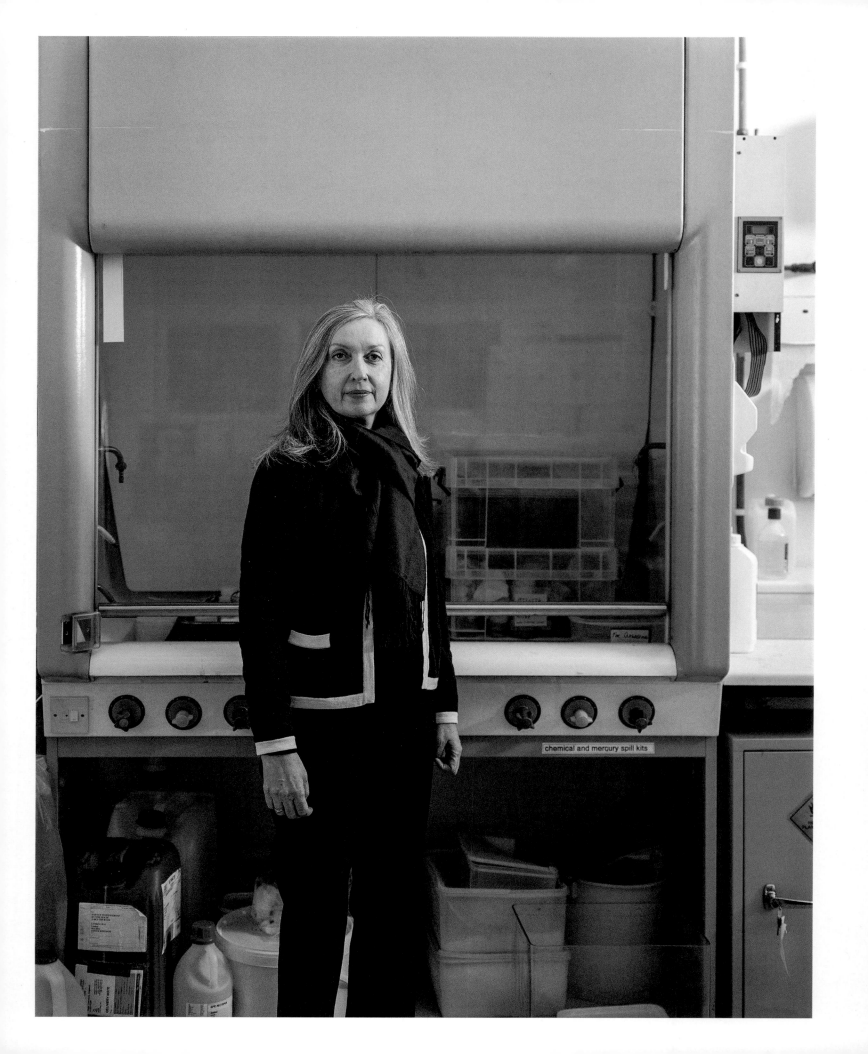

57

I didn't realise before working in television and film just how many things are filmed in corridors and stairways. And they're the shots that connect everything together. So, you've got to walk and talk with an actor. It's more interesting than two people sitting in a room, so people running up the stairs, walking along the corridors, it adds a bit of pace and it's something a bit different, and Blythe has these fantastic long corridors with the glazed tiles.

— Tom Barnes

One of the best was the small passenger lift we could use to go from the top floor down to the basement level. The inside of the lift was decorated with a truly incredible and vomit-inducing brown velour-textured wallcovering, a nod to the '60s and '70s of the highest order. You'd be able to go from the early twentieth century waiting for the lift on the floors, to the 1960s/70s in the lift, and into the 1980s when you got to the basement.

— Hugh Walker

The purpose of the ceramic tiles on the inner walls of the wells of the building was practical and not cosmetic. They reflected light into what would have been a dark cavernous area. The floor, too, was different to anything I had ever seen before. The surface consisted of wooden blocks laid in a herringbone fashion. Clearly extremely durable and easily maintained. The furniture, standard Civil Service desks and chairs, and the quality and style dependent on rank. HCOs (Higher Clerical Officers) had arms on their chairs. Generally, the overall quality of the furniture reflected post-war austerity.

— Alex McDonald

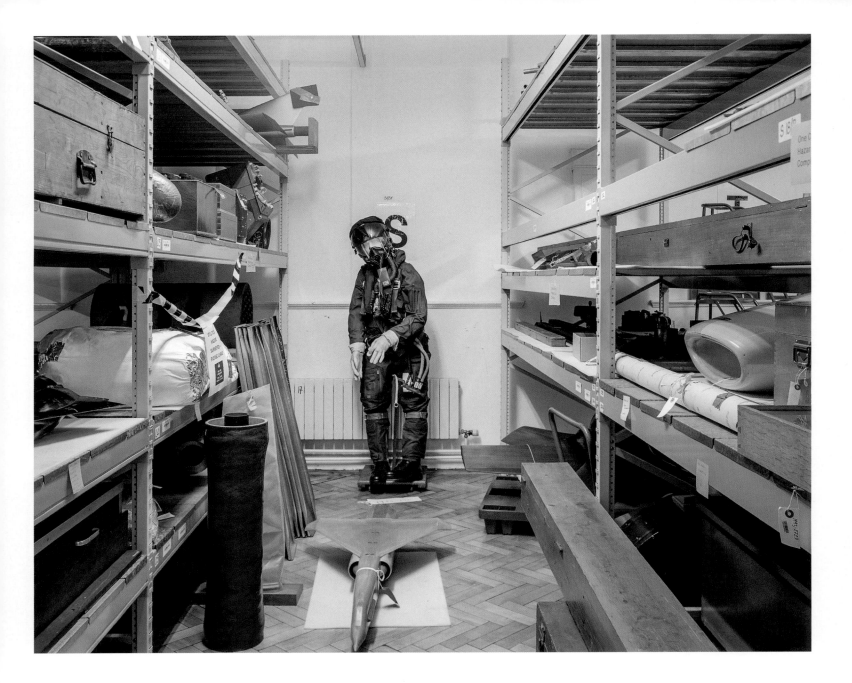

At the end nearest the entrance was another
strange tiny loo, reached by a flight of steps,
which gave it a sense of theatre. I vaguely
remember it being a very '70s green colour.
In front of that was a series of Bronze Age
boats, in huge wooden crates full of those
horrible foam packing chips. Off to the left
was a store that contained objects that had
been recognised as fakes, and down a flight of
stairs was the original Post Office Savings Bank
shop – again, boarded up, but full of spare
bits of racking and ancient office furniture.

– Lucinda Smith

Collecting and Sorting

This has always been a building about collecting and sorting. Both post offices and banks are famous for their sorting. When Blythe House opened in 1903, there were around 9 million accounts with the Post Office Savings Bank, fed from 14,000 post offices around the UK. There were 30,000 ledgers recording these accounts, and the Bank received around 100,000 letters a day. Collecting information and arranging it systematically was a key function of the vast Bank building.

Museum collections are treasures that people do not necessarily think about. On the whole, they are held in trust for the public, and anyone can visit them by appointment. This will be as true for your local museum as it is for the three national museums who kept their collections at Blythe House.

Collections in store are often portrayed as dusty and forgotten, locked away from public view. But this is not the case: there are teams of dedicated and highly specialised conservators, collections assistants, curators, archivists, registrars and collections managers who are ensuring these collections last as long as possible and are ready for research, display or loan to another museum.

There is nothing still about these places. Objects are always rotating on and off display, being researched, being lent to other museums all over the world, and coming back after 50 years in a gallery for a much-deserved rest. As peaceful and static as some museum stores can seem, they are actually hives of important activity.

There has been no bigger museum project in several generations than the departure of the British Museum, the Science Museum and the V&A from Blythe House. The collections are all being moved to individual stores, to new (and much more suitable) homes, and when they arrive, they will be much better catalogued and understood because of all the work that has happened in the decant.

But something magical will have been lost when these treasures of art, design, archaeology, technology, engineering, science and medicine spanning thousands of years have all gone their separate ways.

I do recall that my standard greeting when taking visitors into Blythe House for the first time was 'Welcome to Aladdin's cave'. They quickly realised what I meant.

— Neil Brown

I got a regular job up on 'Ledgers'. Until 1927 all Savings Bank transactions were recorded in a ledger. After that they were recorded on cards stored on purpose-made trays on tables. The ledgers were eventually phased out and stored in shelving along the corridors. … Although they should have been stored in alphabetical order, this was often not the case and some took ages to find. All Scottish ledgers were on the top floor and they were always filthy.

— Dennis Creasey

We went down one very long and quite dark corridor, and turned into one of the stacks to meet a long-time volunteer. She was sat behind a very long desk piled head-height with stuff: old stage designs, posters, a tottering stack of *International Times*, papier mâché models of masks, etc. She was basically buried in this stuff. She looked like she'd always been in Blythe and never moved. She was cataloguing the material. I wondered if it was single-handedly.

— Lauren Fried

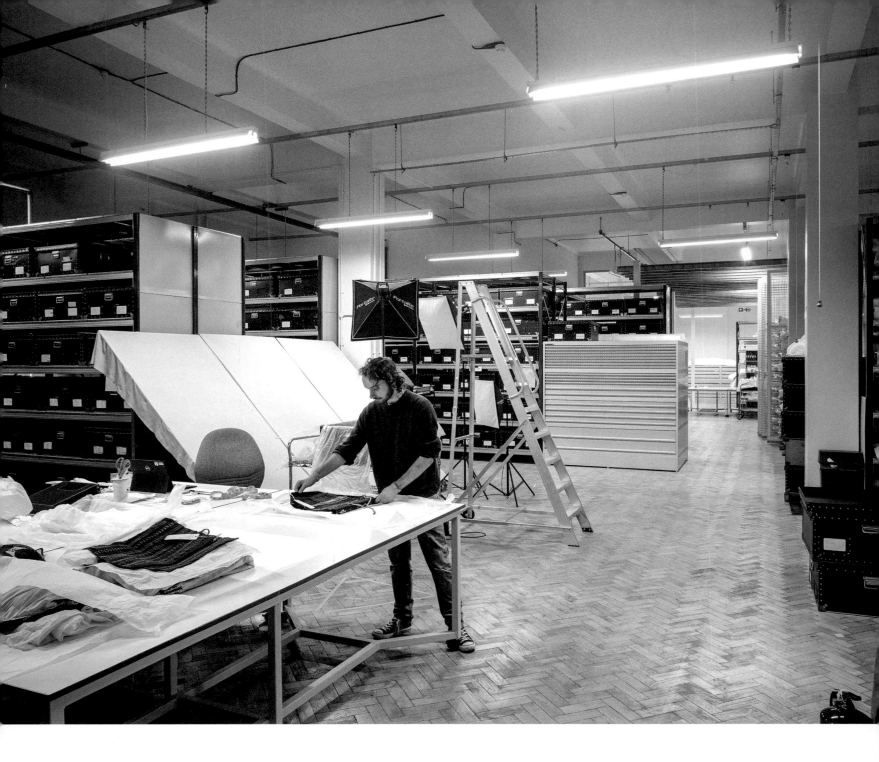

I remember being pleased one day when I
correctly identified a fish trap without
looking at the label. A skill I retain
to this day, although it has never yet
been particularly useful.

— Lowri May Jones

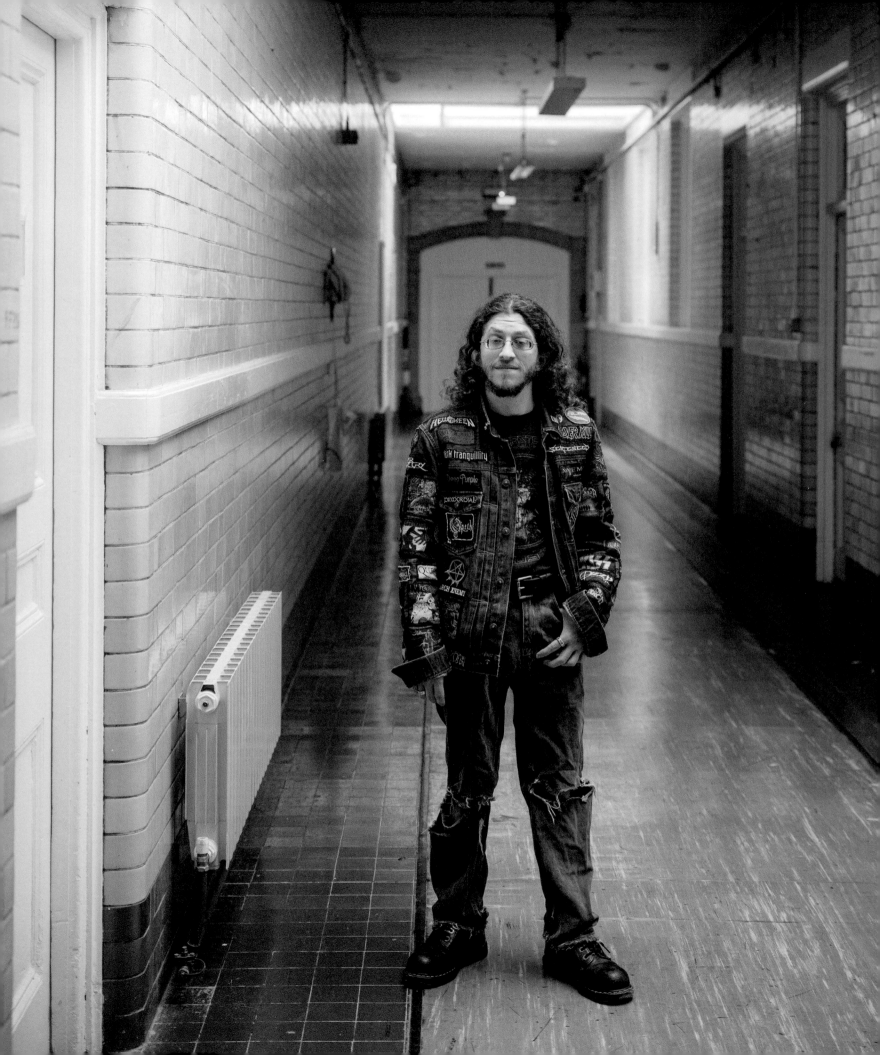

I spent quite a lot of time in my early years
working at Blythe through all the ceramics
collections, figuring out all the not-in-places
and, you know, getting our house in order, and
I absolutely loved that job because it just
meant I spent time with the collections.

— Karen Livingstone

[There was] paperwork relating to the fig leaf
for the statue of David when the Queen was
coming to visit the museum. They had to
produce and make a fig leaf … The department
said if I found that paperwork relating
to that fig leaf, I would get a bottle of
champagne, but it's never been found. That
was to protect his modesty when the Queen
was coming to visit.

— Maureen Mulvanny

In my opinion, Blythe House provided an
imperfect solution to an important problem:
how best to accommodate 'reserve' collections
of relatively small objects. The idea of the
accessible storage of entire collections for
study and research by all interested parties
is one I wholeheartedly approve of – just
as I deplore the whole idea of 'deep storage'
– but it requires that the accommodation
is appropriate, welcoming, convenient
and attractive to staff and public alike.
Blythe House was none of these things, and
for all the hard work and resources that
were poured into it over the years, the view
that our stored collections are an expensive
inconvenience, rather than the dynamic and
popular resource that they should be, has
not been wholly dispelled.

— David Wright

There were cases and cases and cases of
old, wooden objects, all stored gently on
white little pillows, all shelved away.
The Assistant Curator brought the tray out
that should have contained the stay busk.
It didn't, but it did contain a sixteenth-
century apple corer, a tiny chip-carved
baby rattle and a few Welsh love spoons.
I was allowed to touch them. I fell in love.

— Lauren Fried

I always tried to do all I could, within
the time, to meet the wishes of researchers
who wish to study objects in the room and it
was always a great pleasure to me, bringing
visitors in. I'll put a table out, and a light
or something, bring the objects to them and
say, 'I'm sorry I can't leave you. It's not
because I don't trust you, because by being
here it absolves you of any responsibility
should subsequently we find any deficiency.
You know, it won't be anything to do with
you because you were never left alone with
the collection.' 'Ooh', they say, 'I quite
understand' and leave it at that. Very often
they come in and after a few minutes they say,
'thank you very much for allowing us to see
these objects'. And I say 'no, actually you're
the purpose we've got these collections'.
That's why we've got them. If I only had
the time, I'd be doing this every day. 'Ooh,
I didn't think of it like that, they'd say'.
This is what the stores are about. I wish we
could do more of it.

— John Liffen

But it was very interesting because you got
to know the history of every object that you
dealt with. You got to know where it came
from, whether it was purchased, whether it
was gifted, whether it was on loan.

— Maureen Mulvanny

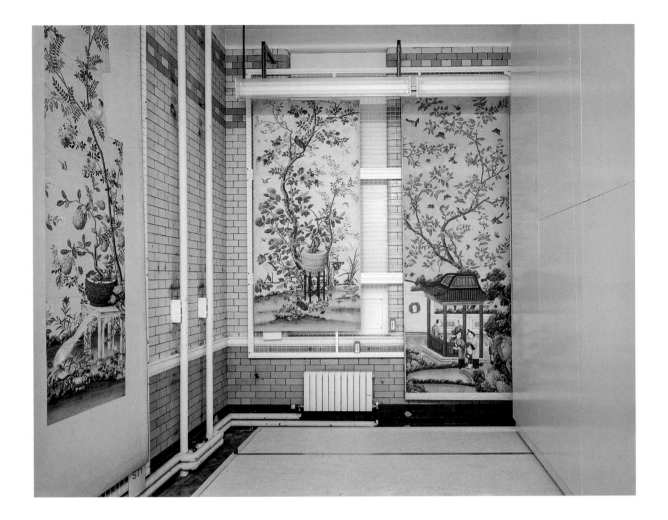

At first my collection was in cupboards that were numbered quite randomly, and records of what was in each cupboard were extremely patchy. After renumbering the cupboards in a logical sequence, it took me six months to record their contents, spending every day in a huge, silent, windowless room with nobody to talk to but a pocket Dictaphone. After a while I achieved a Zen-like state of detachment.

— Roger Bridgman

The last hour of our duty was collating. If you had a Post Office Savings Account and you wanted it to be brought up to date as regards interest, you asked at the post office for envelopes to send it away, one printed with the POSB address and a plain one on which you wrote your return address. Our job was to place the plain one inside the printed one. We had to do 500 pairs and bundle them 50 to a bundle.

— Dennis Creasey

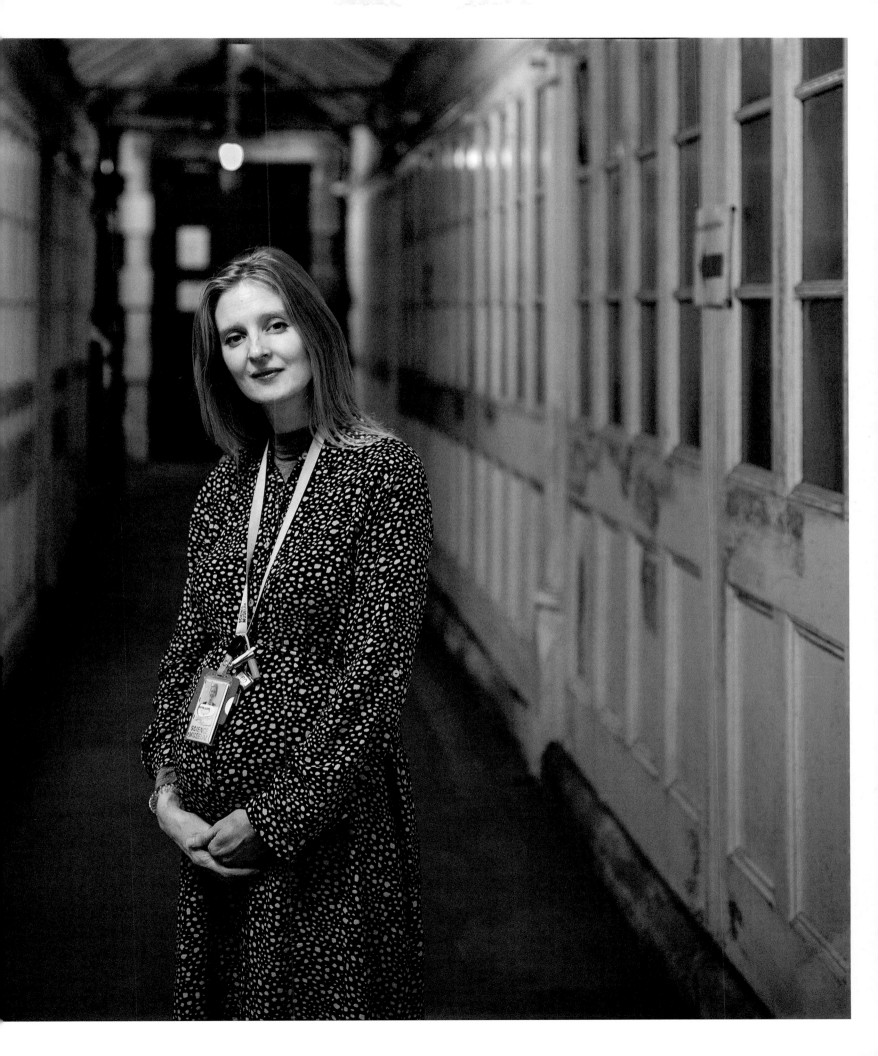

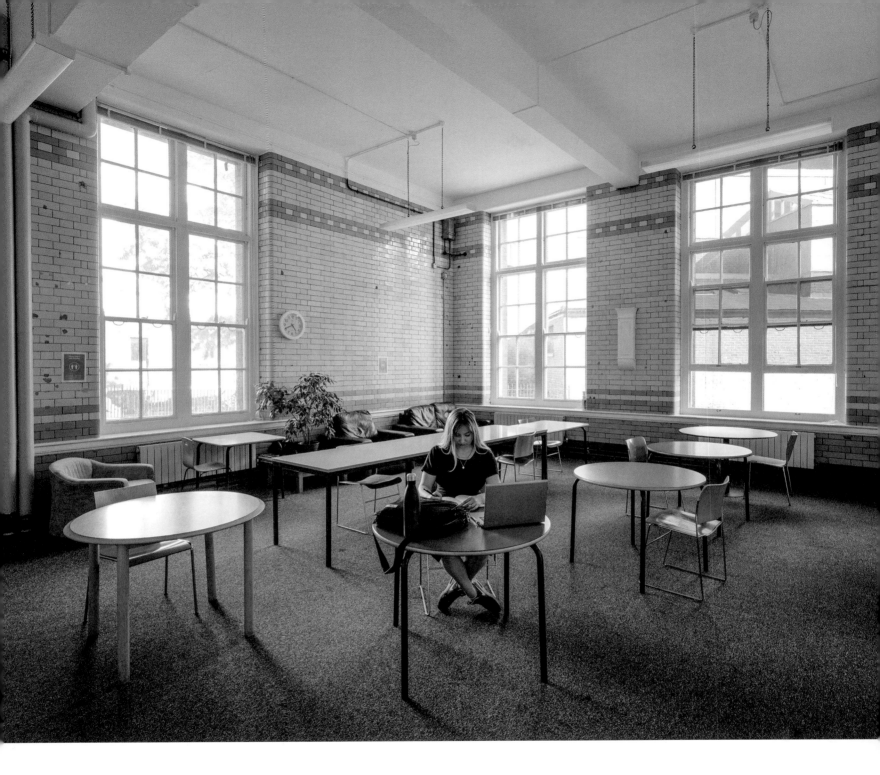

The accounting system in the Savings Bank was quite interesting in that, although it was not all that complicated, no one really knew the whole system and I think it was designed that way to prevent fraud. I had to find out just how the system worked so it could be put onto the computer. So, I spent my time talking to people and trying to figure out how the system worked, and having done that, I passed that on to a colleague who wrote a system specification. That gave the outline of how the computer system would work.

– John Pring

For two days a week we were at Blythe mostly
doing cut-outs for objects in drawers, which
is fun when it's something you do for maybe
an hour, but is one of the dullest activities
imaginable if you do it for two whole days
every week.

— Lowri May Jones

The first room you entered was B1, an infill
at the bottom of one of the inner courtyards,
with a catastrophically leaky glass roof.
The endless leaks had taken their toll on
the poured concrete floor, and you would kick
loose flakes of it as you walked across it.
This was filled with rows of tall benches, for
laying out and working through archaeological
assemblages. At the sides were some desks with
computers and metal cupboards with stationery
(the last resting place of Dymo labellers and
metal-ended treasury tags), and at the far
end were bookcases and plan chests, containing
material relating to the archaeology stored
at Blythe. On the wall next to the door was
a slightly Heath Robinson construction of
wooden frames containing plastic bread trays,
which housed the National Roman Fabric
Reference Collection. I spent many hours
making cut-outs in Plastazote foam to house
the various sherds.

— Lucy Johnston

Spread out across a huge floor were plaster
casts taken by nineteenth- and early
twentieth-century expeditions of major
monumental and palatial features from sites
across Egypt and the Near East. Standing
alone with them, they gave you a connection
to these incredible places as well as the
scholars who worked on them.

— Ben Roberts

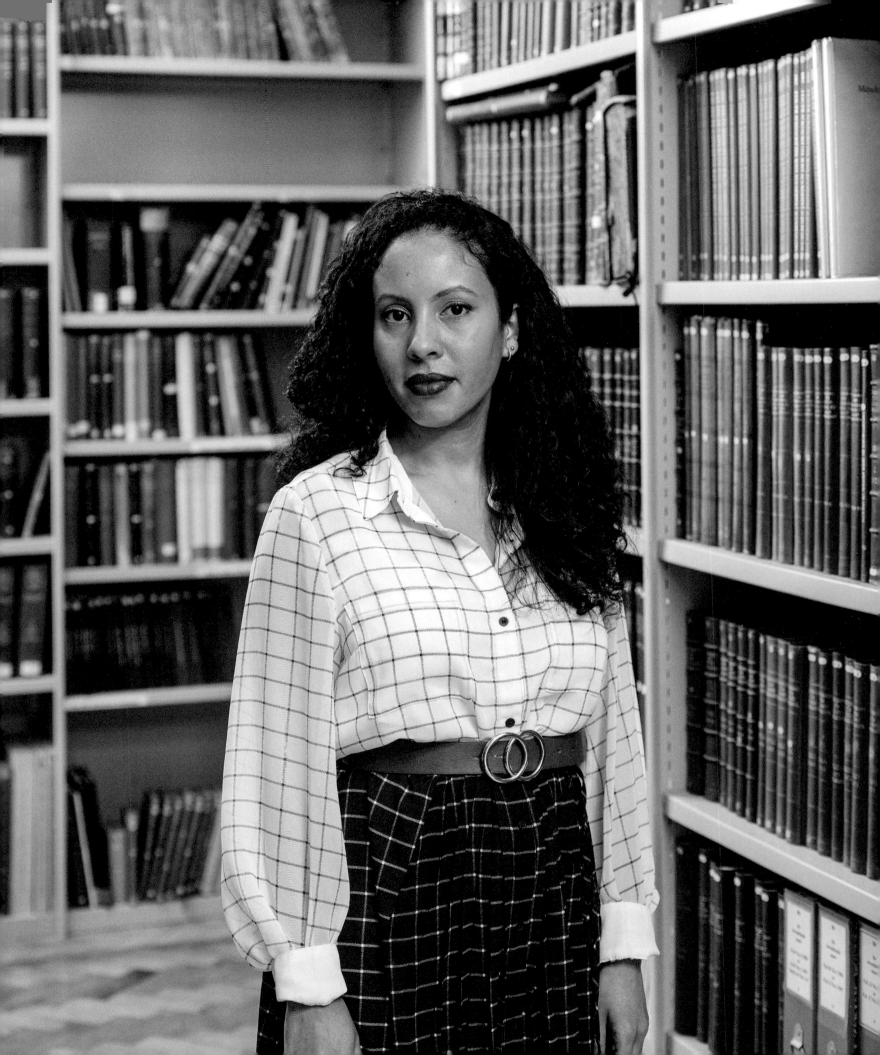

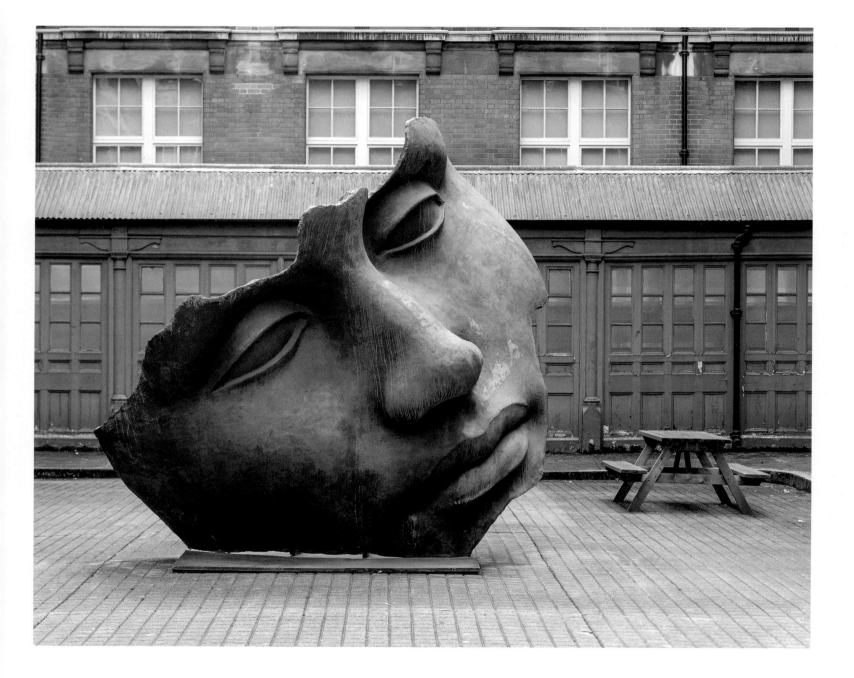

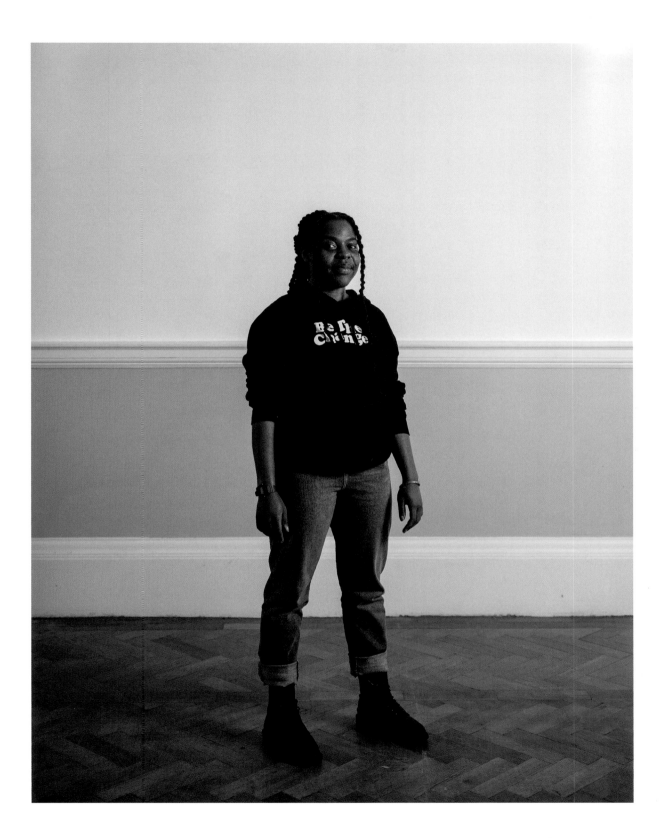

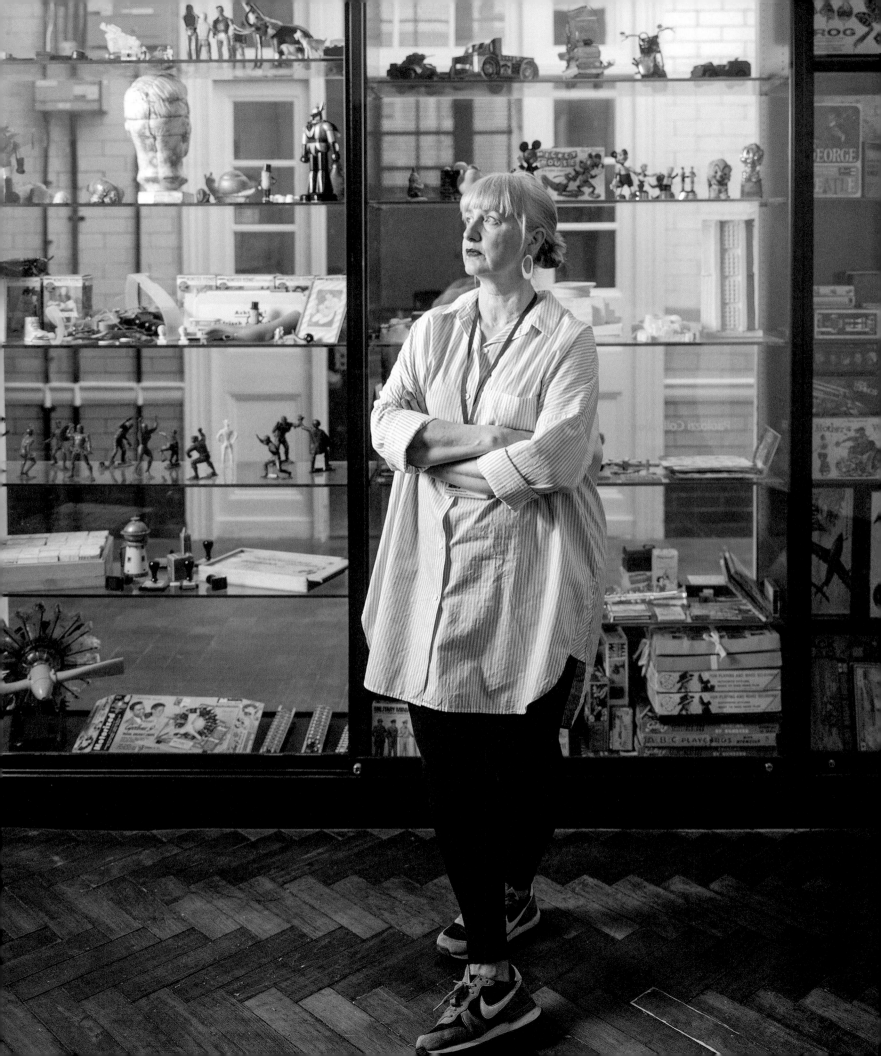

One loan involved a lot of erotic objects
from the medical collection, which as I had
worked with them a lot I had become immune to,
but anyone else in the lab would do a double
take. It was always fun to be able to talk
to friends and family about what you had
been doing that day and say things like,
'Oh, I condition reported an ivory dildo'.

— Emily Yates

One item that I walked past many times a day
was a Peruvian mummy in a large plastic bag.
It was one of the kind mummified in a cross-
legged position and it just sat there, looking
out through dusty clear plastic. It didn't
bother me, but it seemed odd, if I thought
about it, to be walking past a dead body
all the time.

— Jackie Britton

Ccolleagues who worked with indigenous
materials, in particular, stressed the
importance of following certain protocols when
working with cultural treasures. The most
important aspect of this was to remember that
cultural items in the collection are often
seen as living beings with an ancestral
relationship to contemporary communities.

— Shelley Angelie Saggar

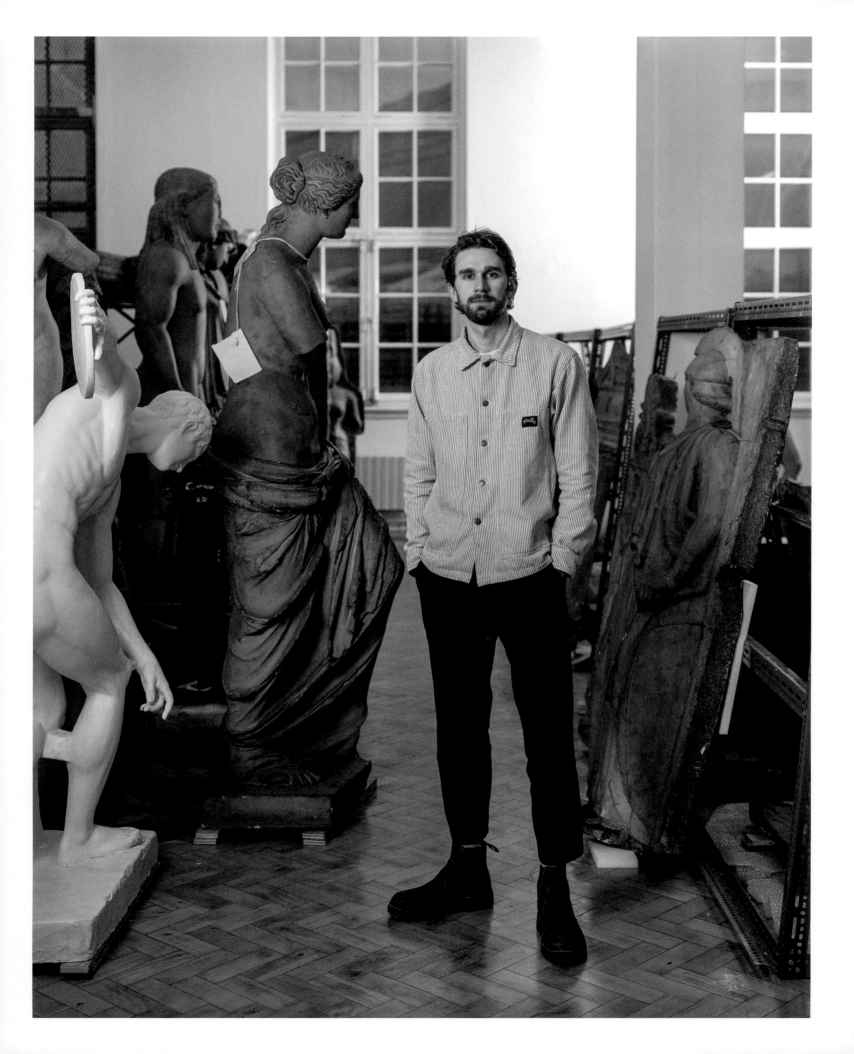

We are obliged to have a collection to
choose from, but it is not actually one or
the other because every object is acquired as
a potential exhibit. For practical, financial,
whatever reasons we can't display it - oh,
I wish we could - every single object I've
acquired I would have liked to put on show.

— John Liffen

There were some lovely objects: a painted
Indian rickshaw, African coffins in the shape
of guns and cars, and giant woven dance
masks. And, infamously, a bag of objects
marked: 'RUBBISH - to be kept'.

— Lucinda Smith

People were surprised at how quickly Blythe
House filled up. One of the problems was that
there was too much junk there. Some of this
was material that curators were going to put
on inventory, sometime, but never did. More of
it was material that had been acquired as a
job lot, and put in the store to await sorting
out, which either never happened, or if it
did, the unwanted material was not actually
disposed of. The problem grew because objects
lost their provenance, or if there was any
paperwork it became separated or lost. From
time to time there were efforts to sort some
of that out. I tried not to make it worse, but
have been surprised at how many 'loose ends'
I left that have been the subject of queries
since I retired.

— Neil Brown

People

Buildings are nothing without people, and this is as true of Blythe House as it is of any home. The Post Office Savings Bank was home to a number of sports and social clubs, both as its own entity and as a part of the wider Civil Service. From 1907 there was a rifle club on the roof of the building, paid for by member subscription. There was also a medical service on-site: provided by the Bank, this was a substantial benefit in the years before the National Health Service.

The Bank also provided a number of restaurants for its employees. For much of its existence, these were segregated: at times by gender, but for longer periods by grade of worker. The restaurant for the Boy Messengers and lower grades, for example, was in the basement, while restaurants for women and for higher-grade workers were largely on the fourth storey, where more of the floors were tiled to facilitate catering.

As a museum store, there was never an on-site canteen (although many local establishments, like George's greasy-spoon café on Blythe Road, achieved semi-official status). But, unlike most modern offices where food and drink are consumed at a desk, Blythe House provided a mess room, where workers could eat their lunch and take tea breaks.

The driving reason for this was pest management. You cannot eat or drink around museum collections, as food encourages pests into the stores, like Indian meal moths or mice. These creatures can do untold damage to precious organic objects, and are constantly monitored and eradicated in museum storage.

A by-product of this system of pest management is that it is not really possible to work through lunch. As a result, both tea breaks and lunch time became highly sociable at Blythe House in the museum era. This was all the more important for those who would often be working alone, in isolated parts of the building. Calling your colleagues to come up for tea became a welfare check for lone workers as much as it was a social occasion.

I was in the building on two memorable
days. The first, in 1990, was when Margaret
Thatcher was unseated as leader of the
Tories. Someone shouted up the Science Museum
stairwell 'she's gone', and I knew exactly
what they were talking about! The second
event was the fall of the Twin Towers in
2001. The Control Room had a television
and we all crammed in to watch it.

— Jackie Britton

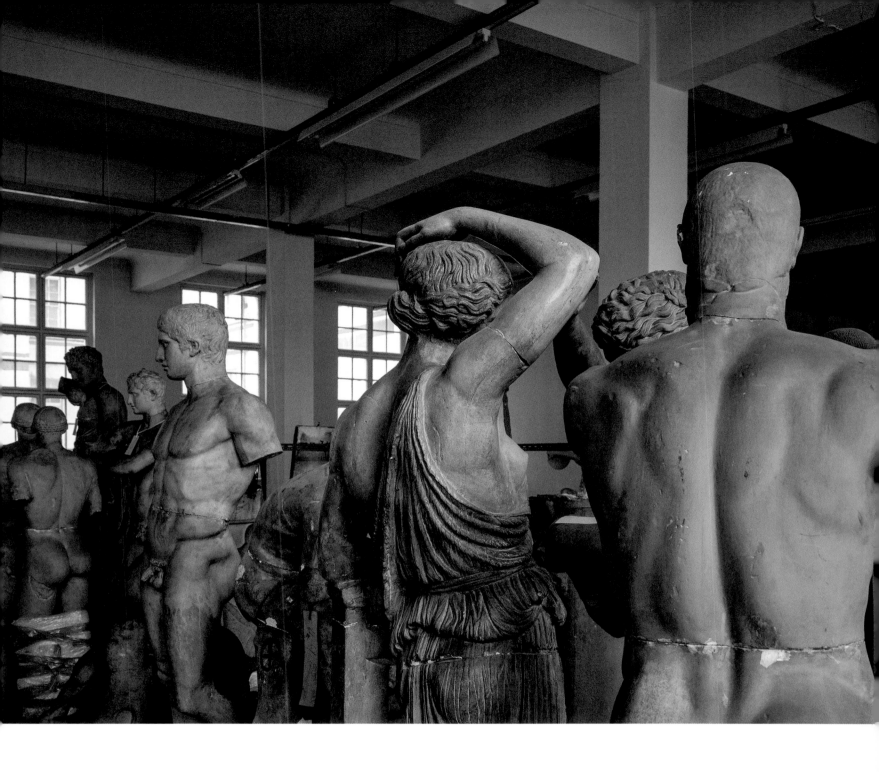

There are lovely, lovely people who work here. I remember when I first recced on *The Halcyon*, we were looking at filming on the roof and because the programme was set during the war, London was all blacked out. And they were really worried that we'd see the glow of all of West London. I spent three hours one night taking pictures of the roof in the dark. It was freezing and I went with a security chap, Nur, and he was telling me that in Somalia they look at the stars for directions and how – because we were looking at the stars – he couldn't work out where he was because we're in a different part of the world, and it was so cloudy.

– Tom Barnes

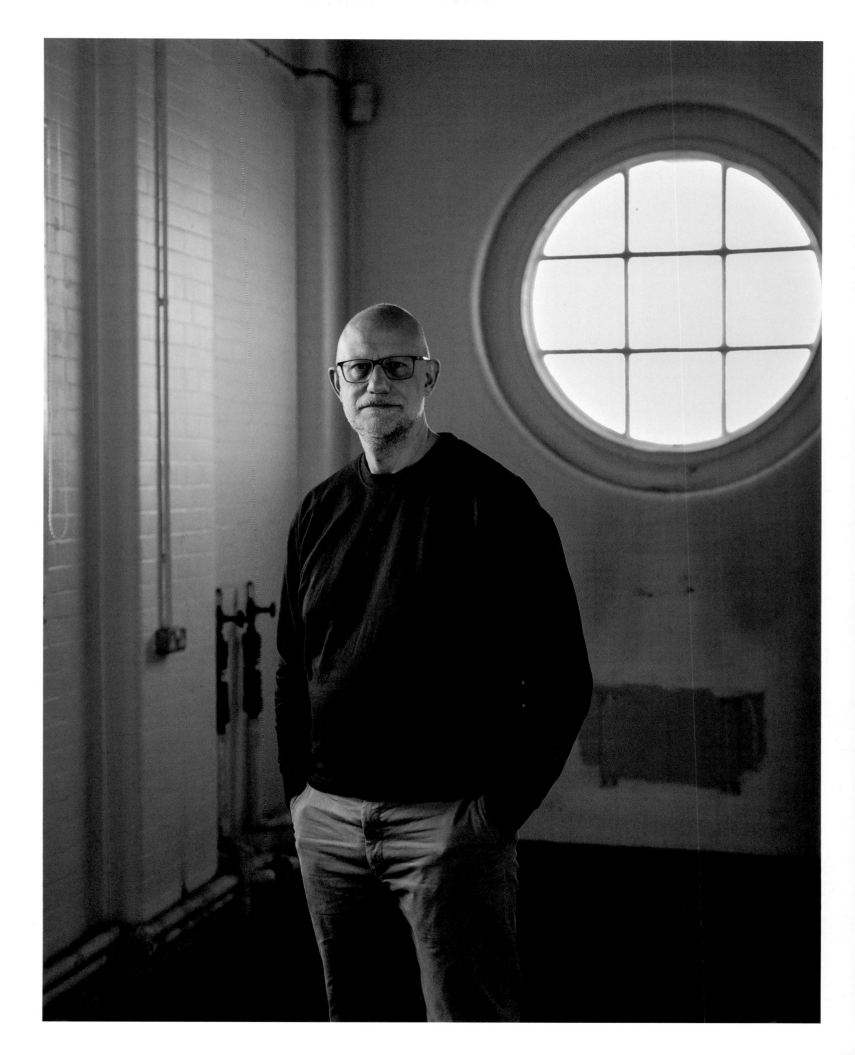

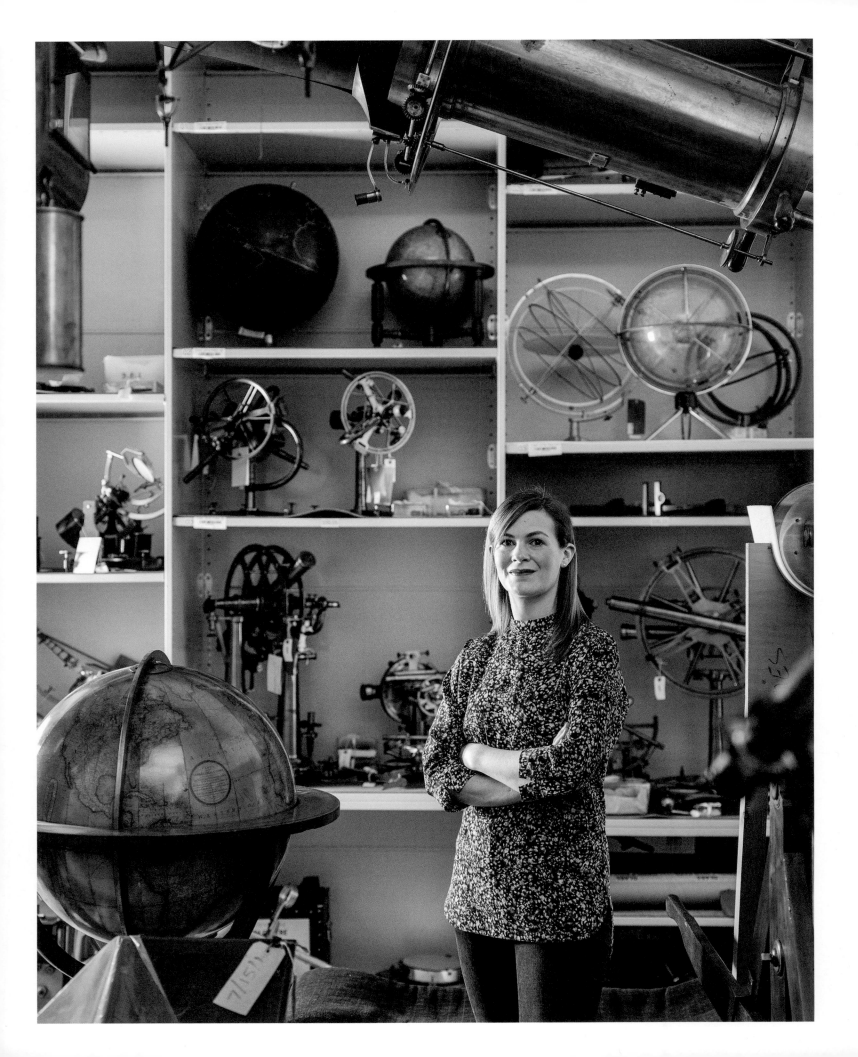

One of the things about the Savings Bank, Kew, and here, was the Gardening Club, OK, where you could get your gardening equipment and things at reduced prices because they were bulk buying, but they also had all sorts of other things they sold in the Gardening Club. And because it was sold through the club you didn't pay what was known as purchase tax on them. So, it was very popular. Things like copper-bottom saucepans, and all sorts of things, which were frightfully hard to come by and very expensive. So yes, it was a good wheeze going on with the Gardening Club [laughter]. You didn't have to have a garden to join either.

— June Fenwick

It was funny as we headed down for lunch on that first day, seeing the clear divisions within the tea room between the museums, with occasional forays by braver individuals to speak to other museum workers outside their organisation. Many a cup of coffee and custard cream was consumed here.

— Ben Harridge

Some of my happiest memories concern the social side of life at Blythe. Myself and a colleague, Kate Dorney, set up a lunchtime craft group in 2005, which met once a week in one of the staffrooms. We would bring our lunch and our craft projects, chat and enjoy the hour together. I remember teaching quite a few colleagues, interns and volunteers how to knit. We also had staff doing other crafts, including crochet, card-making, and model-making for wargaming, to name a few. One winter we all joined in making origami Froebel stars, which was challenging and lots of fun. A couple of years later we also started a board-game club, which ran for about a year. We met once a month at lunchtime and all brought in various childhood games to play. I remember regularly laughing until I cried!

— Amy King

In 2007 there were hardly any shops or cafés in the area. Only the greasy-spoon café, George's. If you asked for the soup, they would open a tin of Heinz. It was in a time warp.

— Keith Lodwick

The mess room was the centre of Blythe House networking. Once the place got busier with more curatorial visits it was great to make sure you were there during the habitual tea and lunchtimes to chat, find out what people were up to, get to know colleagues at the V&A (but less so the British Museum as they had their own mess room somewhere) and generally be available to colleagues. If you were lucky, you might get a slice of someone's birthday cake, too. I also had a lot of fantastic greasy-spoon lunches round the corner at the café whose name I've forgotten, with colleagues. To avoid everyone having to keep their own teabags etc, we used a small sliver of the storage budget to keep communal supplies in one of the mess room lockers, and milk in the enormous communal fridge. There were never enough teaspoons though, of course.

— Jackie Britton

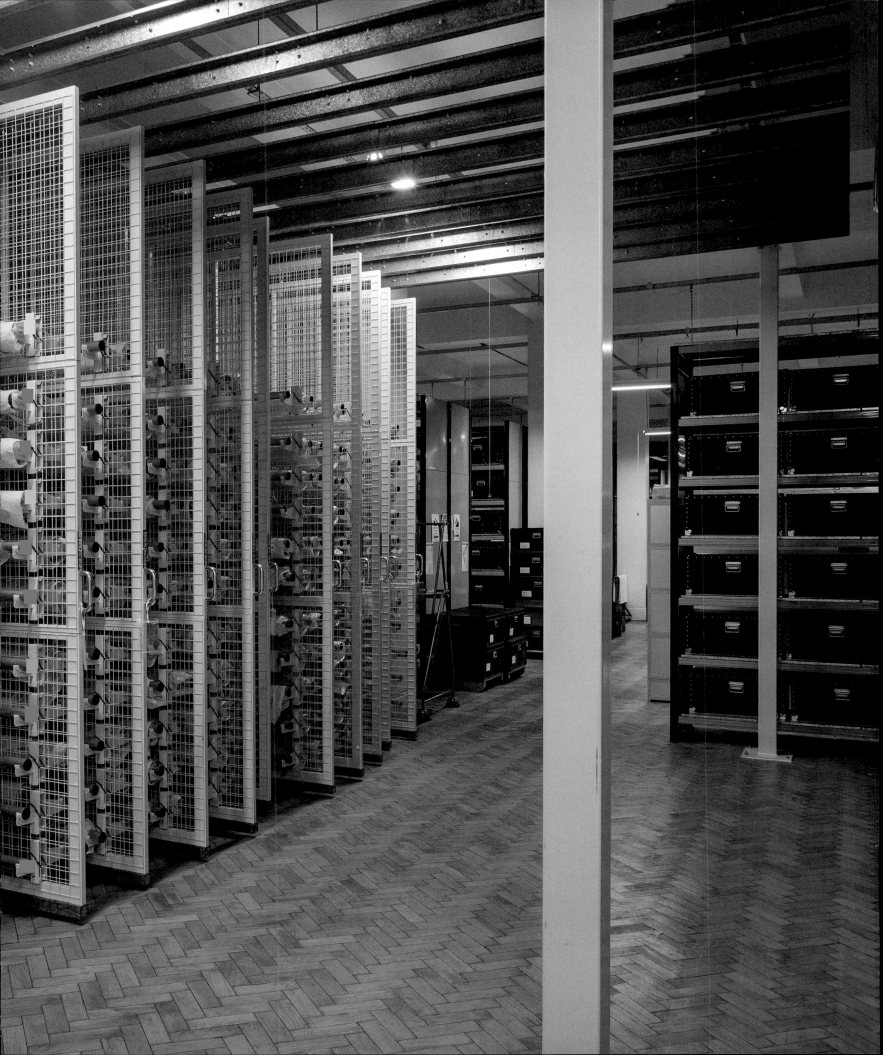

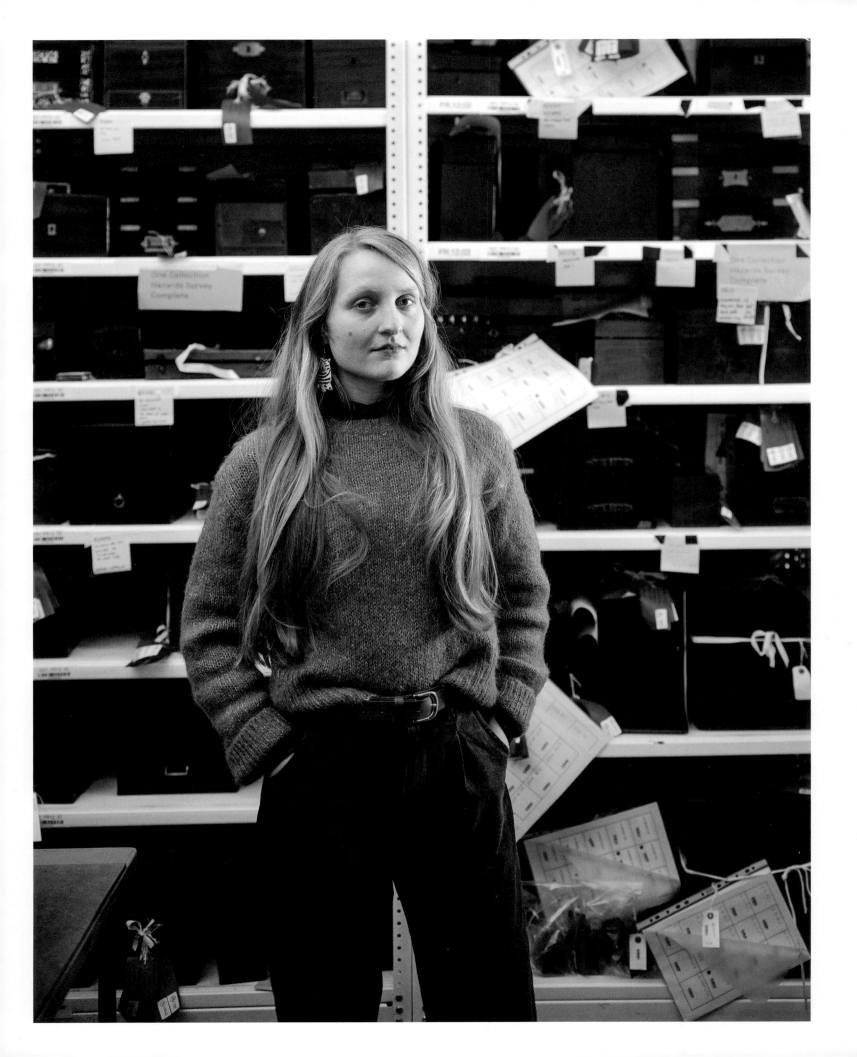

The thing is the Post Office was always very good, really, on staff welfare, you know, and certainly before the National Health Service, to have the advantage of a Post Office doctor you didn't have to pay for.

— June Fenwick

We used to use the canteen and actually it would be about this time of the year you'd go to the canteen and there'd be venison on the menu. And it came from Richmond Park. Back then, Richmond Park had a list - because they culled deer twice a year, spring and autumn - to whom they sent the venison, and the POSB was on it. These days they sell it off to the local butchers. It was a bit surprising to go into the Savings Bank canteen and see venison on the menu.

— John Pring

The highlight of my time as a curator there (apart from ordering new shelving): runner-up in the Blythe House darts competition.

— Doug Millard

I received two book prizes, one for being the top boy at the Savings Bank and one as runner-up at the snooker. The reason that I got the latter was that the boy who beat me went to prison. 'The Institute' was a sports area in the basement entered by stairs at the side of the Post Office counter. It was a large area containing a snooker table, table tennis and a boxing ring. There was also a closed-off area that contained a rifle range for adults only.

— Dennis Creasey

Cold chisel, stamped M
Tube expander, 5/8"

passed to me by a representative
of The Maudslay Society*. I should
have a note or a letter concerning this.

The suggestion is that these items
came from Maudslay, Sons & Field.
Even if so, I attach little importance
to them, but they belong to the
Society and must be [...]

 M.T. [...]

* who ~~[...]~~ left the [...] + I
could not refuse them [...]

From: [...]

HE UNIVE[...]
BIRMING[...]

[...]d of Physics and [...]
Research

[...]ton
[...]ham B15 2TT
[...]Kingdom
[...]e 021 414 3344
[...]4 6709/4577
[...]52 UOBHAM G

[...]hool
[...]C. Morrison

[...]21 414 4662/

=============

[...]Field, left
[...]n officially
[...]92-719].

[...]amped 7/8C
[...]hine Tools

[...]aper reamer by
[...]d as a part of
[...]ber? Otherwise,
[...]ty I should do
[...]I suppose that
[...]y are happy for
[...]her small tools

EX-GUODESK
(SCC's OFFICE)

Oh, I sat at a table, doing some boring job, while the married men there doing the same boring job went on at great length about 'Why should you have the same pay as me? You've only yourself to keep and I have a wife and three children'.

— June Fenwick

Before I arrived, there was on a wall outside the Savings Bank a slogan in big white letters saying 'ADP [Automatic Data Processing] team go home', so I suppose that was a sign of resistance. And there was an annual sports day at the Savings Bank. It took place in the Civil Service sports ground at Chiswick. I can't remember what time it started, but it was sort of late afternoon, so presumably people had finished their jobs early. It was a full sports day: running races and that sort of thing. There was also a tug-of-war, so the ADP team decided to put in a tug-of-war team and some of our team members weren't actually all that young. But there really was a feeling of them and us. And we won. We trained out the back [of Blythe], you know. There's a bit of space and there was a tree. So, we tied the tug-of-war rope to the tree and we'd go out there at lunchtime and have a practice pulling against the tree. But we won.

— John Pring

It was one of those teams where a lot of relatively young people had been recruited at the same time, and worked together constantly, so as a group we were all pretty close while we worked together: loads of going to the pub after work, karaoke, the Olympia beer festival. It was a great job to have for me as I'd just moved to London, and I absolutely loved my first year here. The job got boring after a while - it wasn't challenging enough - but overall the experience was great.

— Lowri May Jones

The Civil Service in London was staffed largely by young men and women from all parts of the UK who were making their way in life away from home. Consequently, all of the departments had very well-organised social and sporting facilities and the Bank was no exception. Within the Blythe Road building there existed an indoor small-bore rifle range. There was also a strong swimming club of which I was a member and we enjoyed competitive racing against other departmental clubs.

— Alex McDonald

People were always shocked that I could get
special privileges from security, like car
parking for a visitor, or even use of their
own staffroom TV during the 2002 World Cup,
when the matches were on at seven in the
morning. This was no magic touch. I just
treated them as close colleagues with the
respect they deserved. I also learnt (from
John K. and Giuseppe, as well as from the
night shift) that Blythe House had no ghosts.
I still didn't envy them having to go past
the puppet collection in the dark.

— Guy Baxter

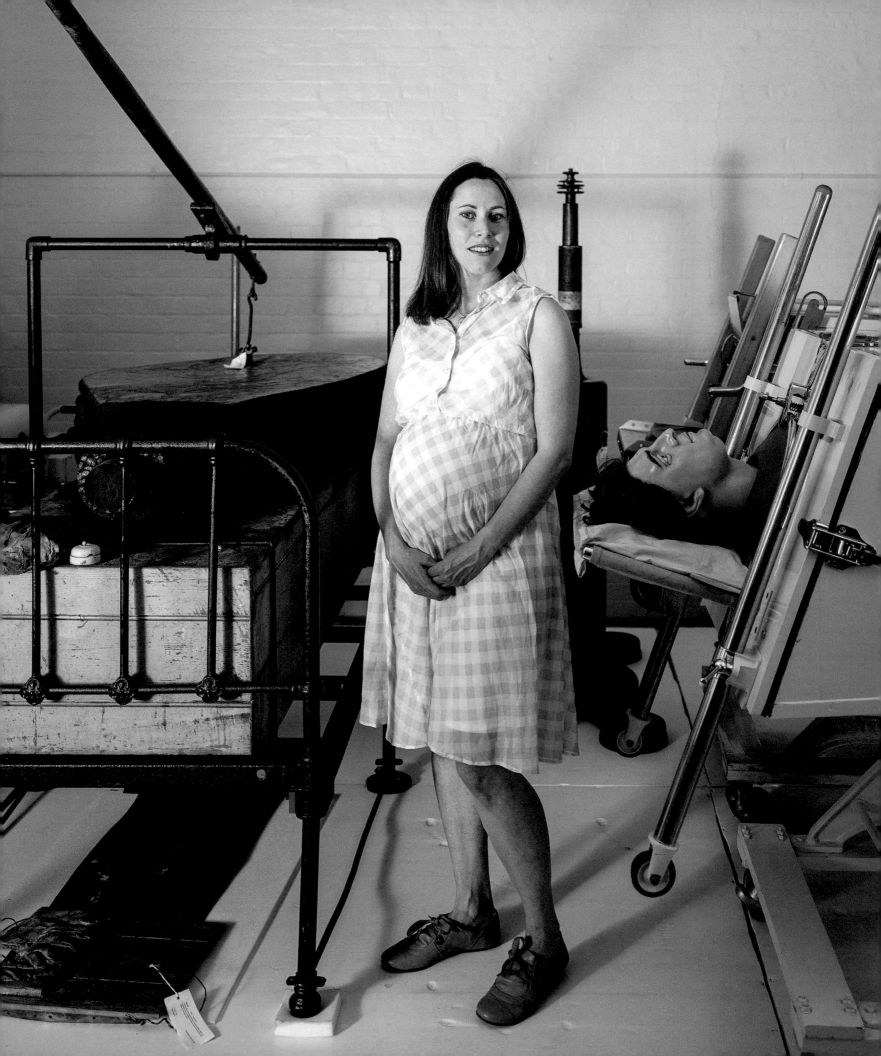

I organised the first summer party on the roof in 2007 with Glenn Benson. It was a hassle to get all the furniture up the spiral staircase (!), but it looked great when we got everyone up. We put up bunting. It has a fantastic view across London and staff from all three museums came. It was the beginning of the summer party. I feel pleased that I initiated it and up until 2019, it was still going strong.

— Keith Lodwick

I remember the board-game nights with the British Museum staff and slowly watching the museums come together as the decant progressed, especially with staff switching between museum roles! So many laughs in the tea rooms, every day pre-Covid, and also the parties we had!

— Kerry Grist

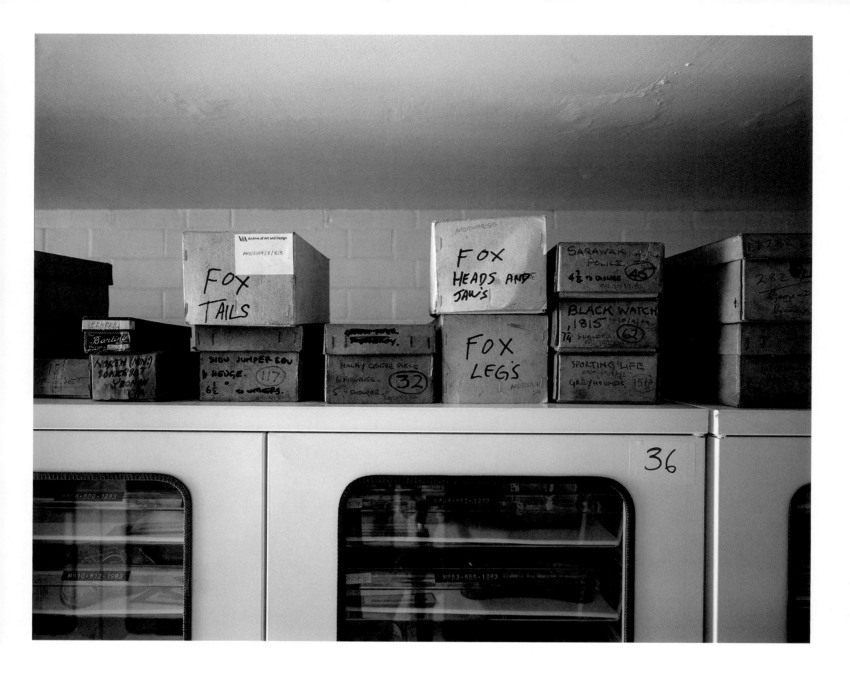

I made wonderful, lifelong friends from our
shared joy and trauma of Blythe House.

— Terri Dendy

Danger

Blythe House does not look like a particularly dangerous building. But a common theme of people's time there, from when it was the Post Office Savings Bank, to being used by Euston Films and for storage by the museums, was the significant danger experienced during their work. Even Blythe's trademark glazed brick tiles are mildly radioactive.

Early in Blythe's life, a rifle club was established. In 1907, paid for by employee subscription, a range was installed on the roof. This was not purely for the hobbyists: 200 staff were members of the Auxiliary Forces, and the Boy Messengers, some as young as 13, were instructed in military drills as part of their official training at the Bank.[1]

The unhappy twin of the foundation stone to the left of the main entrance is the war memorial to the right, with the names of 93 employees who died during the First World War. A memorial for the Second World War was originally situated inside the building, but moved with the POSB to Glasgow, where it remains.

A number of Post Office Savings Bank employees told harrowing stories of the Second World War, playing out in and around their lives at Blythe House. The basements of the building were reinforced about 1938 for use as bomb shelters, and a number of bombs caused significant damage to the surrounding area.

Much like beautiful Edwardian buildings, museum collections are not often associated with danger. However, many contain serious hazards. Asbestos is common in technology and engineering collections, as are carcinogenic oils such as polychlorinated biphenyls. Historic pest control can be problematic, with taxidermy and fabric objects often treated with methyl bromide or arsenic. Objects can also be radioactive: historic medical equipment, objects from the testing of nuclear bombs or from Marie Curie's laboratory, and even clock faces with early glow-in-the-dark paint can contain radioactive elements. All of these hazards (and many more) need to be carefully managed by museum workers, especially in a project like the decant of Blythe House, where every object is packed and moved to a new home, possibly disturbed for the first time in decades.

1 'Post Office Savings Bank rifle club', *Volunteer Service Gazette* (6 March 1907), p. 279.

The building was often a challenge to work in
when it was very hot or cold. The fourth floor
could be boiling hot or freezing cold. Often,
we would save basement projects for summer,
as it was a steady cool temperature. The audit
of the radioactive store would be planned for
late autumn, never winter, as you would be too
cold to tick off the audit spreadsheet.

— Emily Yates

Most of our time as Collections Assistants
at Blythe House was spent in the dark and
dingy parts of the stores that hadn't been
looked at for years. We donned hazmat suits
as we dealt with an old pharmacy that had
been boxed up, almost dying when contractors
let a trolley slip down a slope and crash
into our trolley full of chemicals.

— Terri Dendy

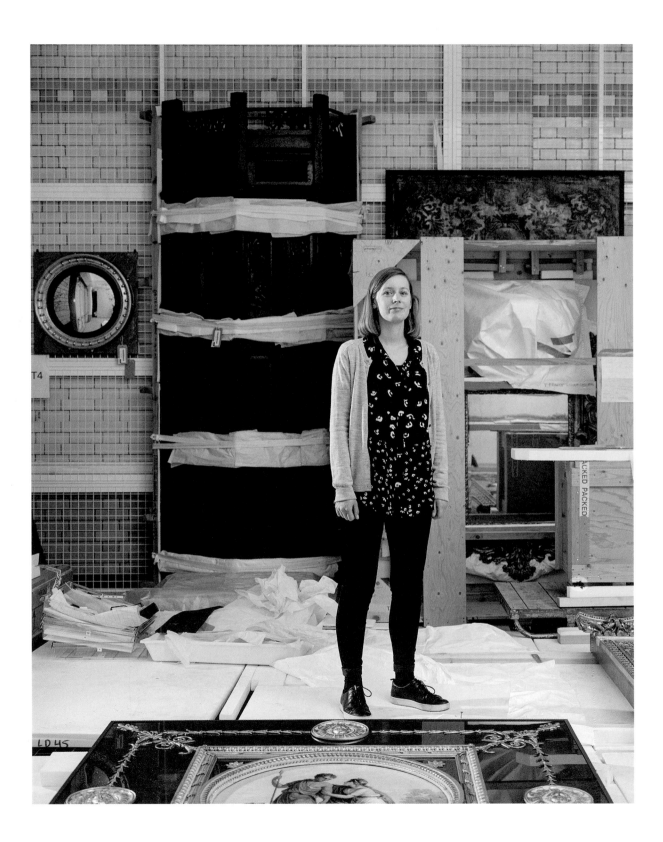

I was in the staff restaurant, having my
lunch one day, when the air-raid sounding
went. And since the restaurant was on the
fourth floor, no way could you get down to
the basement, to the shelter. If you were
in the restaurant, instructions were you
got under the tables, which we did. And I got
under my table and realised my pudding was
still on the top, so I put an arm out, felt
around on the table until I found my pudding,
and then got it and ate it under the table
reading my P.G. Woodhouse. It was a lemon curd
tart. Mind you, lemon curd tarts in wartime …
it was a strange mixture because the lemon
curd tended to be made with dried egg … it's
not like tart au citron, you understand.

— June Fenwick

I had a great time at Blythe House looking
through original newspaper cuttings in
scrapbooks not available elsewhere [about
stuntman Arno Wickbold and his death during
a stunt]. After Arno died, I found from the
cuttings that, remarkably, loads of people
volunteered to take his place. Obviously, it
was quite poignant as the circus where his
accident happened was actually at Olympia,
just round the corner.

— Clare Wichbold

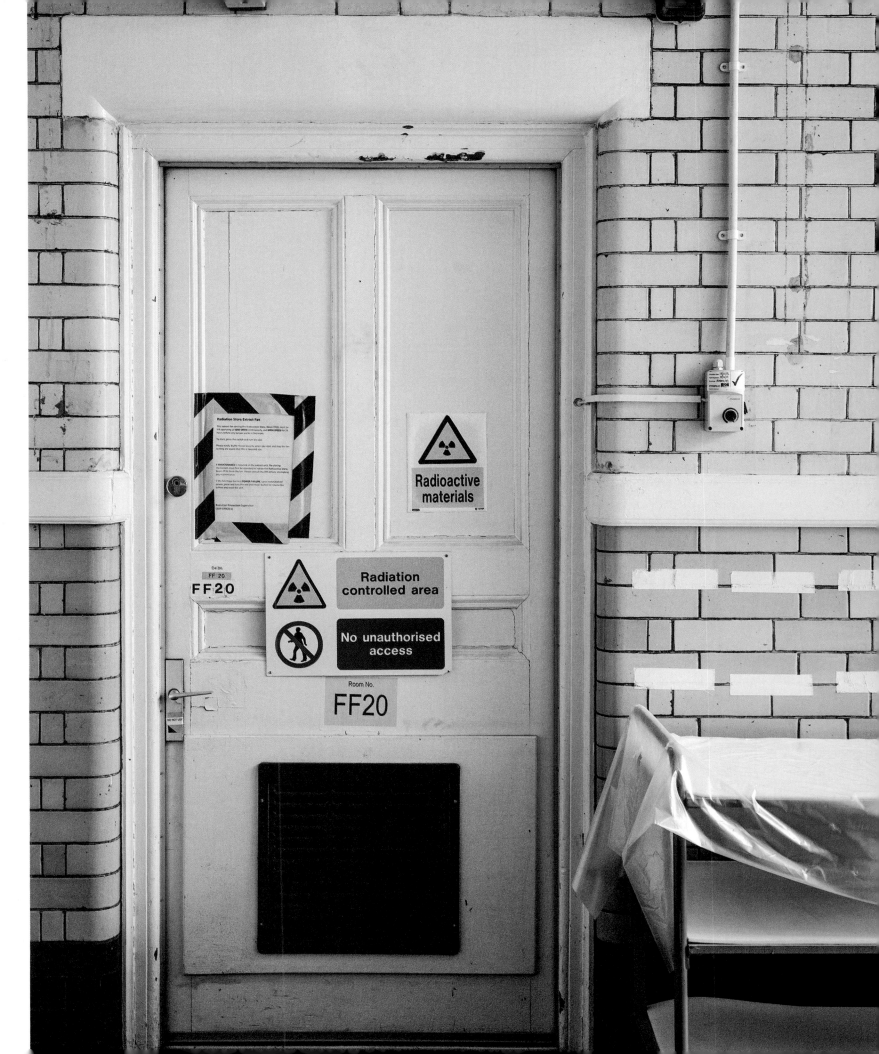

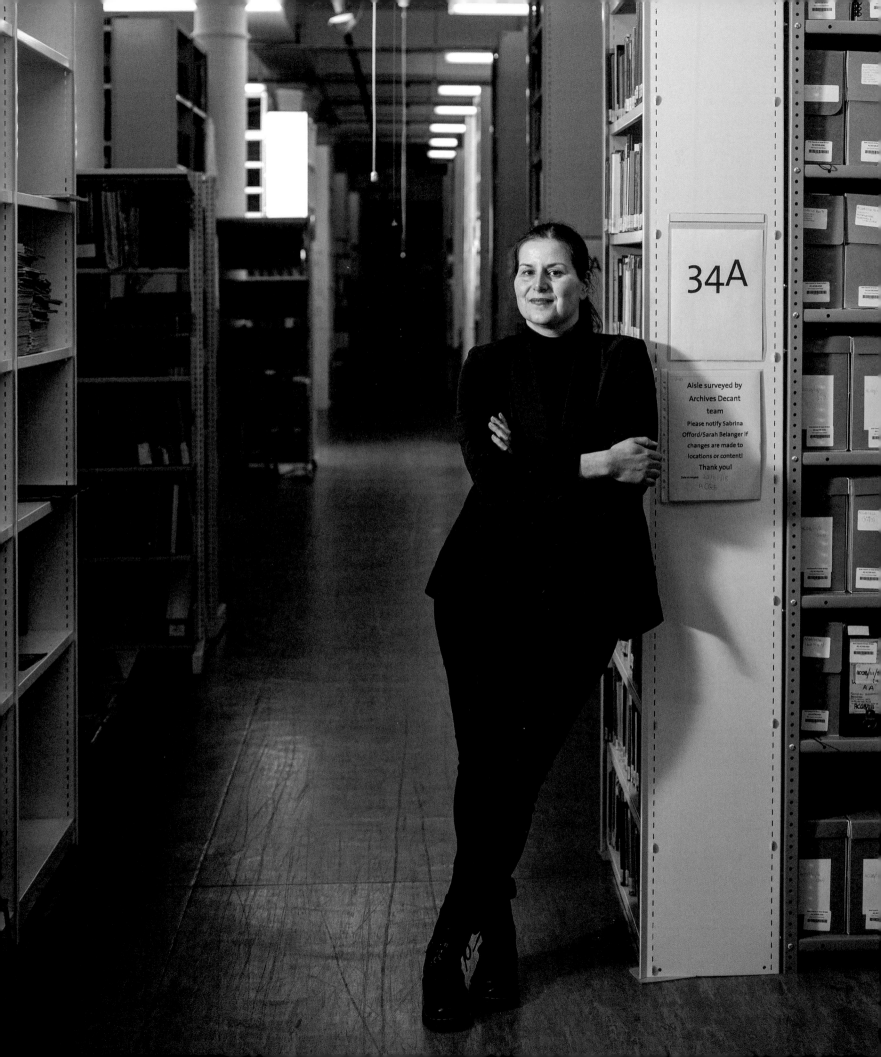

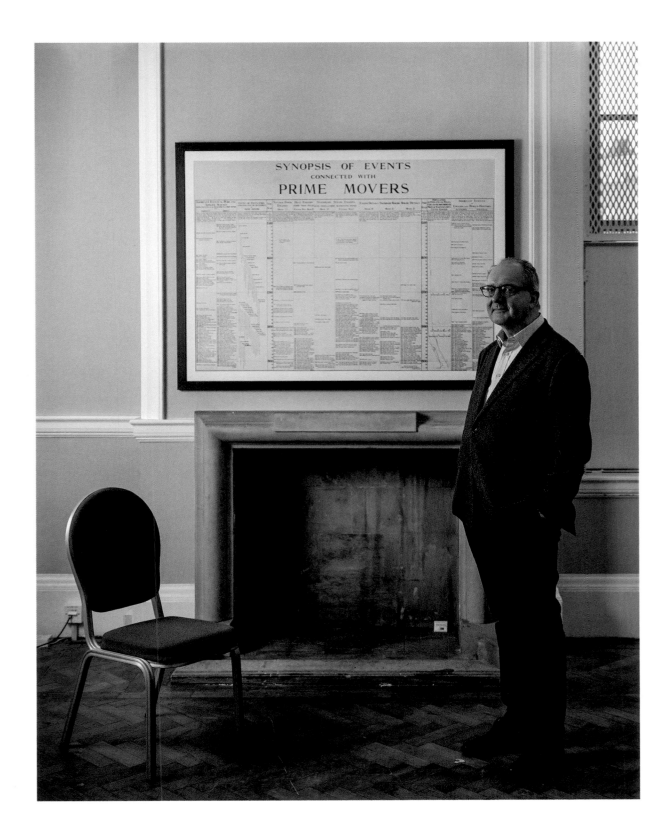

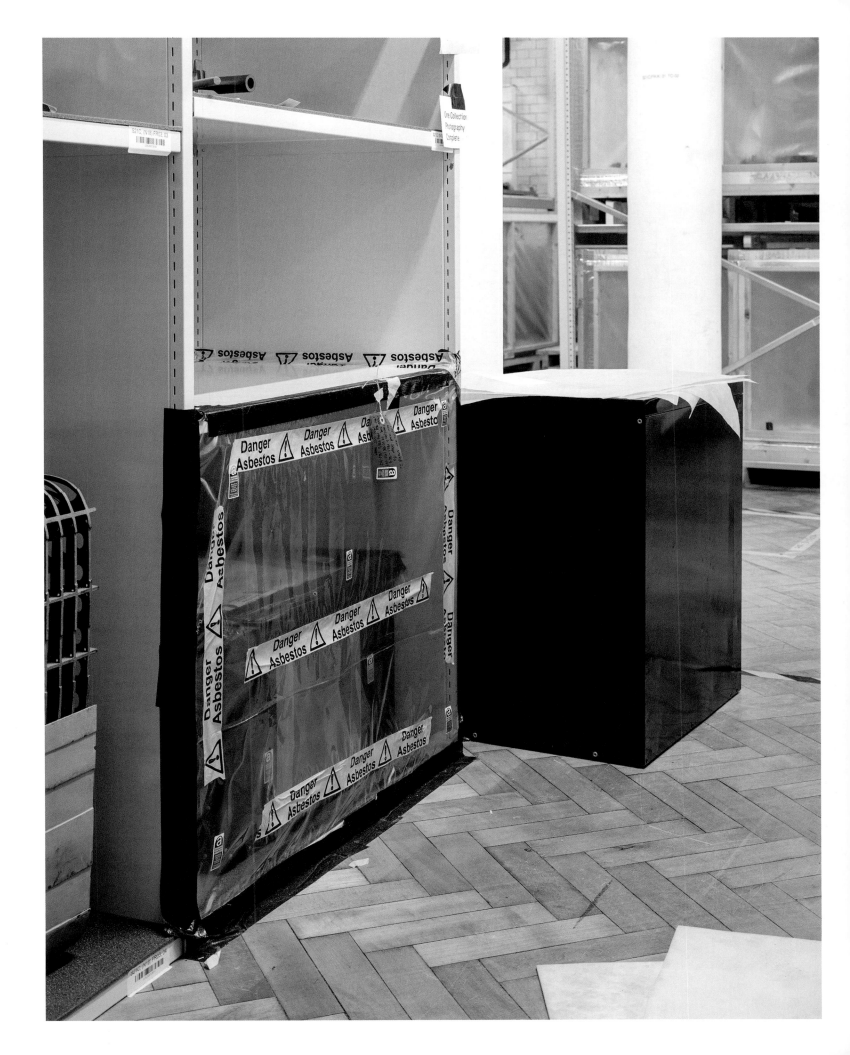

Obviously, if we're dealing with any guns
or explosions while filming, we have to talk
to the Met police and we get a CAD Number,
because you don't want someone walking in
the front of Blythe with fake guns and all
the police turning up.

— Tom Barnes

On the Fulham Palace Road I ran for the bus
and tripped and fell, and as I fell somebody
stepped on my back, and hopped on the bus.
He got on and I was late. I still carried
on to work and of course we had our matron
and nurses on-site. We had a huge sickbay
and I was sent down to get my knees and my
elbows bandaged, and I thought I'd be sent
home, but I wasn't. I was sent back to work
and had to sit and work for eight hours.

— June Fenwick

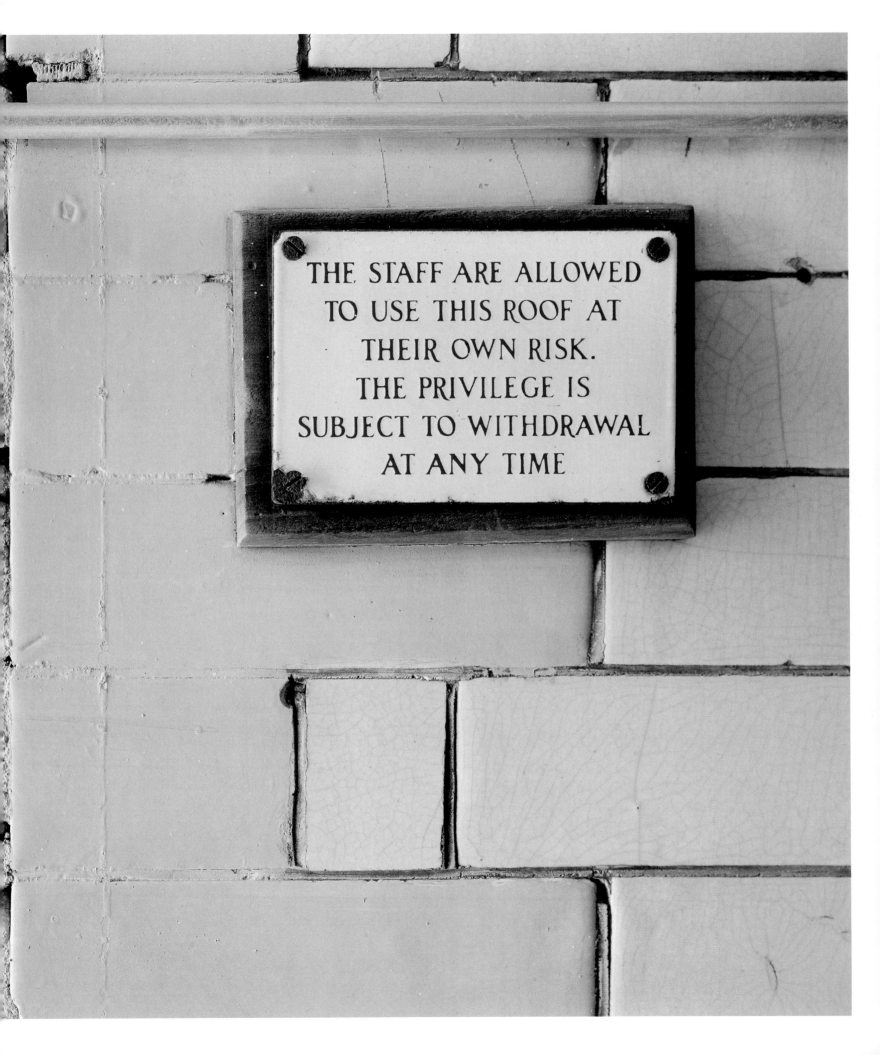

It's just not as it was in 1962. It's totally
different, but we still have the tiled walls
and we still have the flooring, partly. It's
been cleaned in some parts, but I was just
saying earlier, when they cleaned those floors
all those years ago in 1962, they used to
re-varnish. I think it was varnish they used
to put on that floor, and you'd be sick for
about a week. I don't know what the process
was, but whatever they put on there, the
fumes were horrendous. You got it first thing
in the morning and then you'd feel quite
nauseous, but then as the day went on you
got used to it, I guess. There was no health
and safety in 1962.

— Maureen Mulvanny

I remember that the conservators in the lab at
the Science Museum were working on preserving
flayed tattooed flesh when we visited, which
made me feel a bit bilious!

— Lucinda Smith

We had a matron and nurses on-site. It was
like a hospital ward actually. Well, it's not
dangerous work, but when there's 5,000 people
working in a building, something's bound to
happen at some stage. But they were taken
care of. Albeit they were sent back to work,
but there you go.

— June Fenwick

We used to go up on the roof via a small goods lift, which was rope operated and had no doors on one side. On one occasion when we wanted to go down, we all squeezed in and the lift started to go down a short way and stopped. We guessed that we had not properly shut the doors. It was decided that the best thing to do was to put Georgi Goddard, who was the smallest, up through the roof hatch to close the doors properly. To do this he had to stand on a small ledge inside the doors. As he did this, the lift went down with Georgi clinging to the inside door handles. When we reached the basement two boys had to go up to rescue Georgi!

— Dennis Creasey

Some [parts] of the collection had their own inherent risks. Most notable was the vast collection of poisoned arrows from Borneo. These came in various shapes and sizes and, although 200 years old, they still held a certain fear factor. Occasionally, the records on the collections system gave terrifying toxicology reports, listing the hazardous substances that were present.

— Ben Harridge

And, of course, there was the day of the rocket, and I was up a ladder. It was in the days of the V-1s and V-2s. V-1s, known as doodlebugs, they did know when they were coming over. So, there would be an air-raid warning. With the rockets [V-2s], they were so fast and so high up when coming over, that they literally came out of clear, blue sky. And I was up the ladder, getting stuff off the filing racks, when one fell near Kensington High Street. The whole building shook. My ladder slipped sideways and so I grabbed the shelving with one hand and one foot and was suspended up there until rescued. A good cartoon sketch that one, I think.

— June Fenwick

On one occasion Ron Barnet and I (he joined the same day as me) were walking along Hammersmith Road on our way to work when we heard a flying bomb overhead when the engine stopped. This meant that it was coming down. We immediately laid flat on the pavement between a sand bin and a high wall until we heard the explosion. Still safe and sound, we carried on to work.

— Dennis Creasey

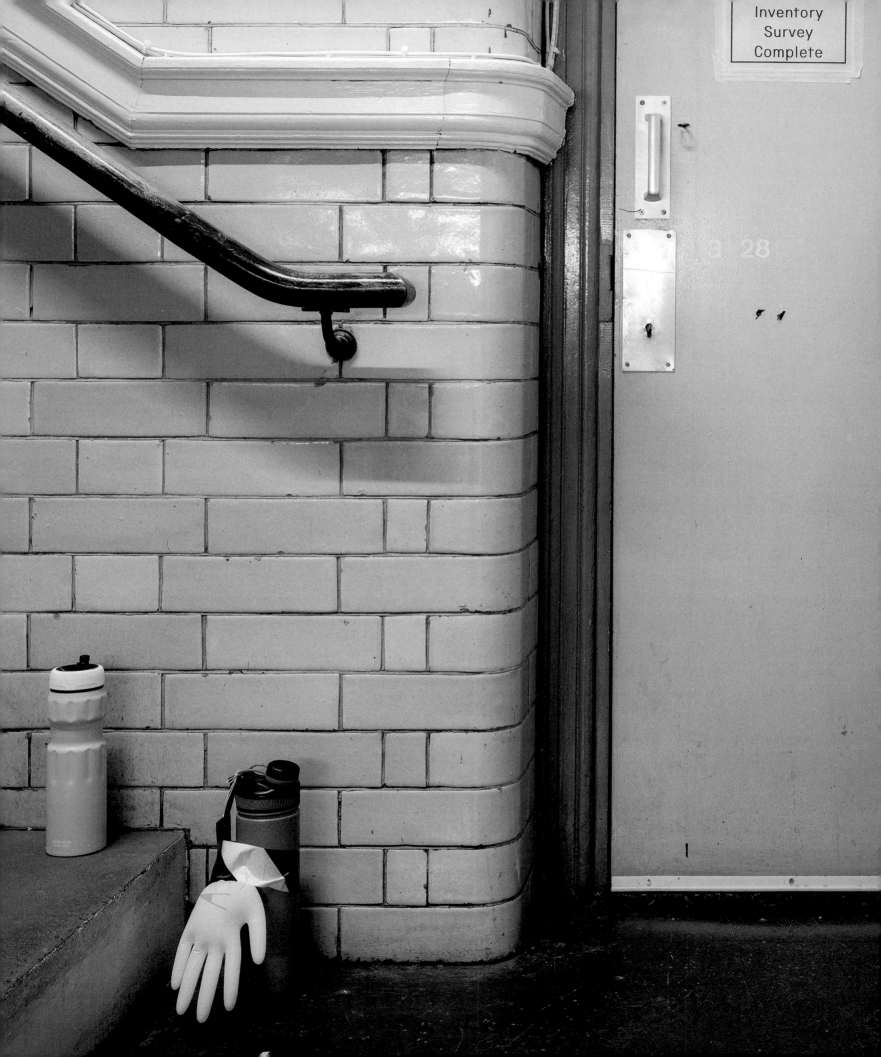

Inventory
Survey
Complete

A bomb also exploded opposite the front of
the POSB that blew in some of the windows.
This blew glass splinters onto the file cards,
which meant that they had to be very carefully
cleaned. It also caused the death of the
newspaper seller who used to be at the
junction of Blythe Road and Hammersmith Road.

— Dennis Creasey

Atmosphere

Blythe House is not just a beautiful and complex building to look at, but is equally beautiful and complex to perceive with your other senses.

It is hard to capture the atmosphere of such an unusual place in words, but many contributors were keen to try and convey the sense of place they felt within the building. People spoke of it as eerie, lonely and unsettling, especially when working alone on the museum collections a long way from colleagues. In contrast, the business of the Post Office Savings Bank was crowded, but very formal, rather than casual or friendly. The architectural quirks of the building played into almost everyone's perceptions of atmosphere, however.

Smell was a strong theme for many of the museum workers and researchers who experienced Blythe House. Gathering collections of like objects together, often in a confined space, leads to unusual odours building up and hanging in the air. This might be something familiar, like the smell of old paper in an archive room, or something much less so, like the acidic smell of cellulose acetate film degrading, which is so recognisable that it is known as 'vinegar syndrome'.

Plastics, medicines, fabrics, dirt, metals and more, all added to distinct pockets of scent throughout the building. Many spoke of smells lingering on hair or clothes, of a smell telling them that something was wrong, or of being able to find their way around the building based on smell alone. Others had recognised familiar smells from Blythe House in other places, too.

There are not many places where you can smell history, but Blythe House is one of them.

Whenever I think of Blythe House the first
thing that comes to mind is the strong smell
of the newly varnished floors in the storage
areas. That was what struck me on the first
day, as well as the warm fug of the mess room
where the friendly warders took their breaks
and entertained visitors.

— Roger Bridgman

The atmosphere in branch was quite strict
and dour, really. It wasn't … let's put it
this way, there was no hilarity. It was
all very serious.

— Maureen Mulvanny

Well, on the ADP [Automatic Data Processing]
team it was very informal and that was the
way I had been used to working. … You were,
independent is the wrong word, but you were
given your job and you got on with it, but
that was in our room. Outside, in the Savings
Bank, it was much different. There was a lot
of formality, the hierarchy was very important
and everyone above you was a mister. I
remember seeing [the room] of the big ledger
branches. It was just huge, so long: 50, 100
yards long? You've seen them, all the clerks
sat there in rows facing the same direction,
heads down, hush. And their supervisor at the
end of the room sitting with his arms folded
looking down. It was a Victorian world really,
in a Victorian building. Well, not quite
Victorian, but almost.

— John Pring

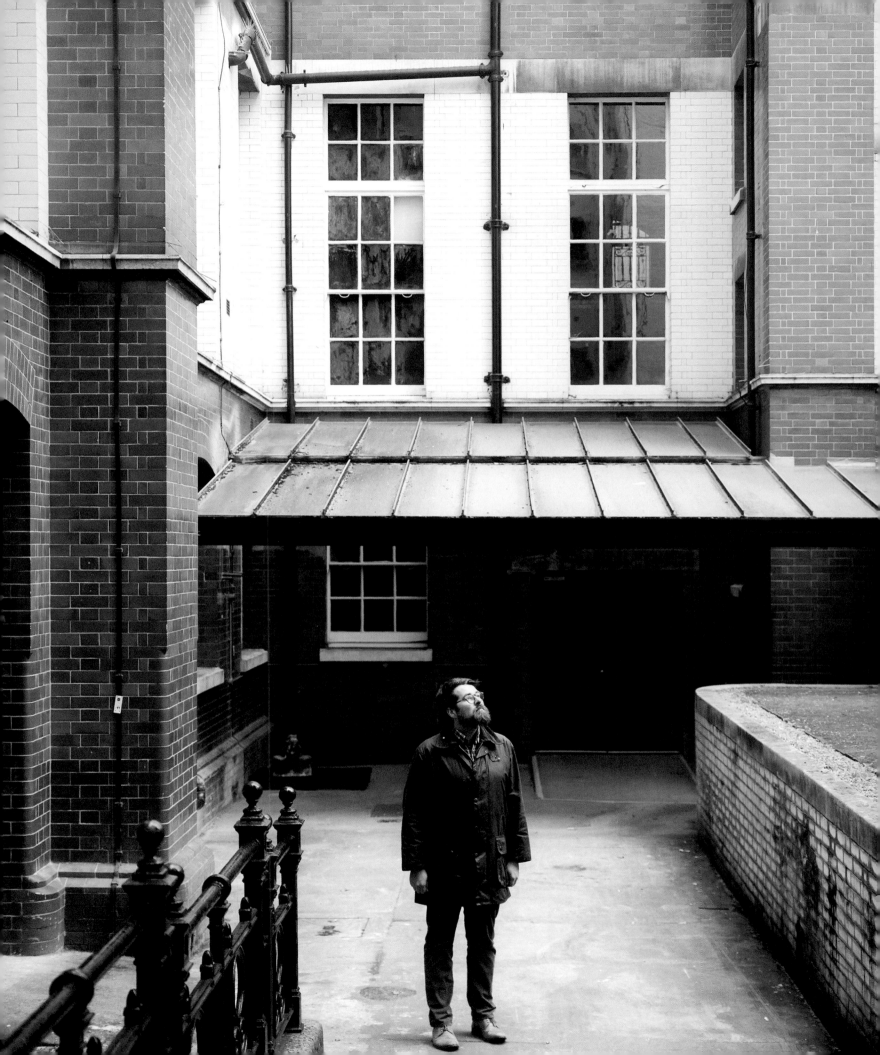

The corridors echoed and the basement in particular carried all sorts of different smells. One of the Wellcome rooms reeked of cloves.

— Doug Millard

For me, Blythe had a distinctive and oddly comforting atmosphere. As I approached the long ground-floor corridor on my way to the second and third floors, I looked forward to the feeling of calm purposefulness that enveloped me once I passed through the last heavy door. Is there a Blythe smell? I think there may be, but what I most recall is a feeling of stillness.

— Edwina Ehrman

I remember the smells of each room. I once smelt [room] B34 on the Paris metro!

— Kerry Grist

The one feature I will always remember is the different smells in the spaces. The smells of some rooms, for example B27 Therapeutics, would linger in your hair and clothes if you were in them for a whole day. You could even leave a jumper in a room and be able to smell where it had been. Prosthetics, plastics and human remains had the most unique and pungent scents, but everywhere was different. One day I could immediately smell there was a problem in S17, as I could smell the coal remnants that had fallen from one of the blocked fireplaces. The corner of the room was covered in a fine coal dust. Luckily, the objects were mostly wrapped up.

— Emily Yates

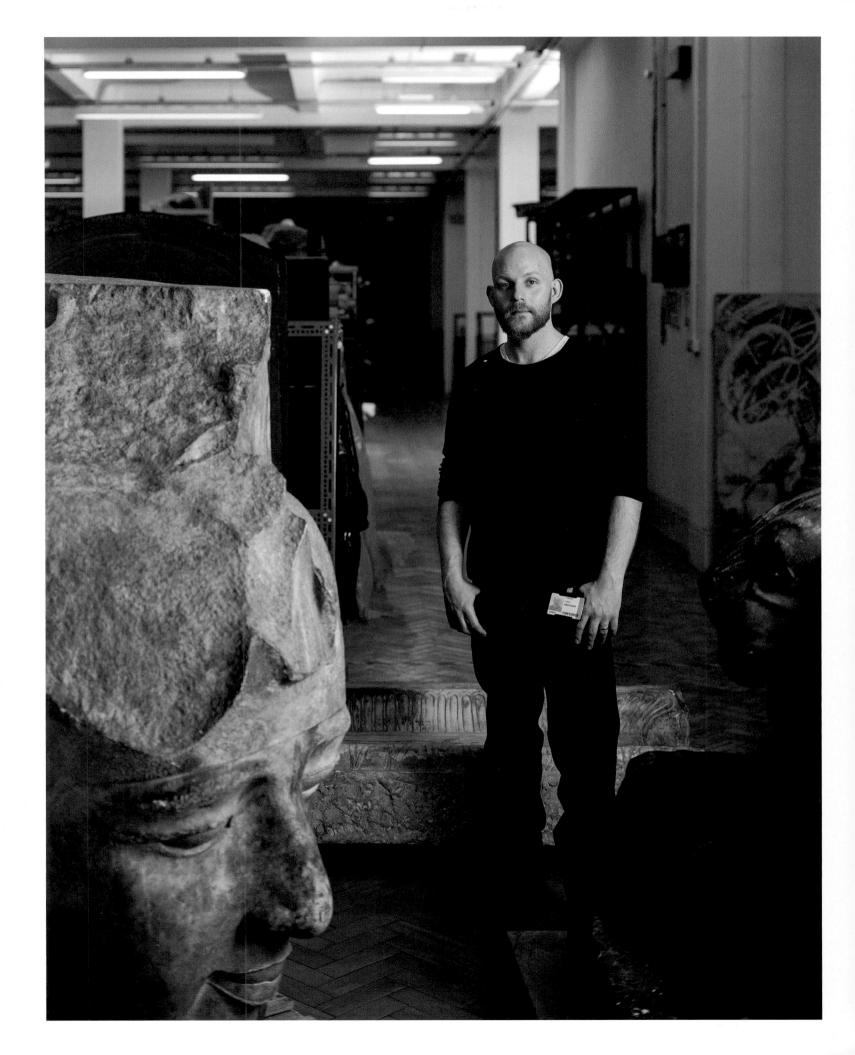

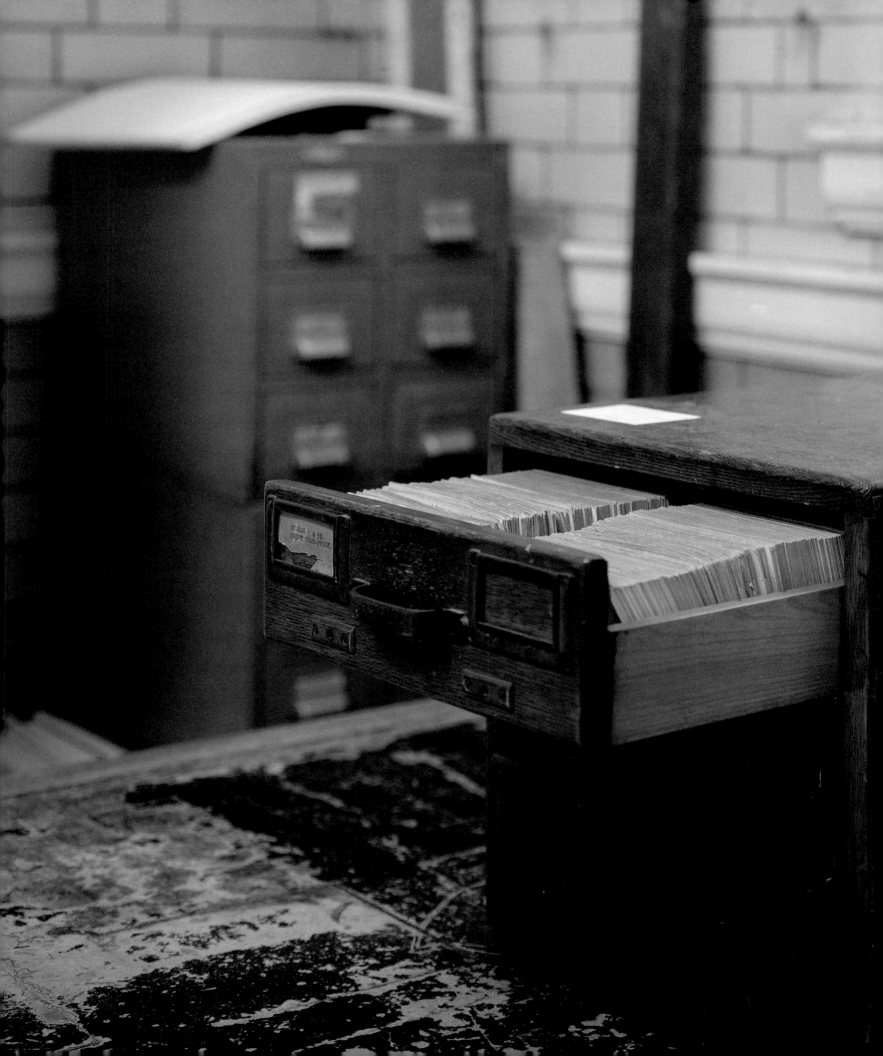

Another room that I could have identified blindfold, just by the smell, was the dentistry room. I've had visitors with dentist phobias unable to stay in there, so much did it still smell of a visit to the dentist. My waxing lyrical about the horror of foot-pedal-driven drills probably didn't help.
– Jackie Britton

I spent a day with the team rebuilding the padded cell for photography. It gave off quite a particular smell! And the smell clung to your hair after a day working in the basement.
– Terri Dendy

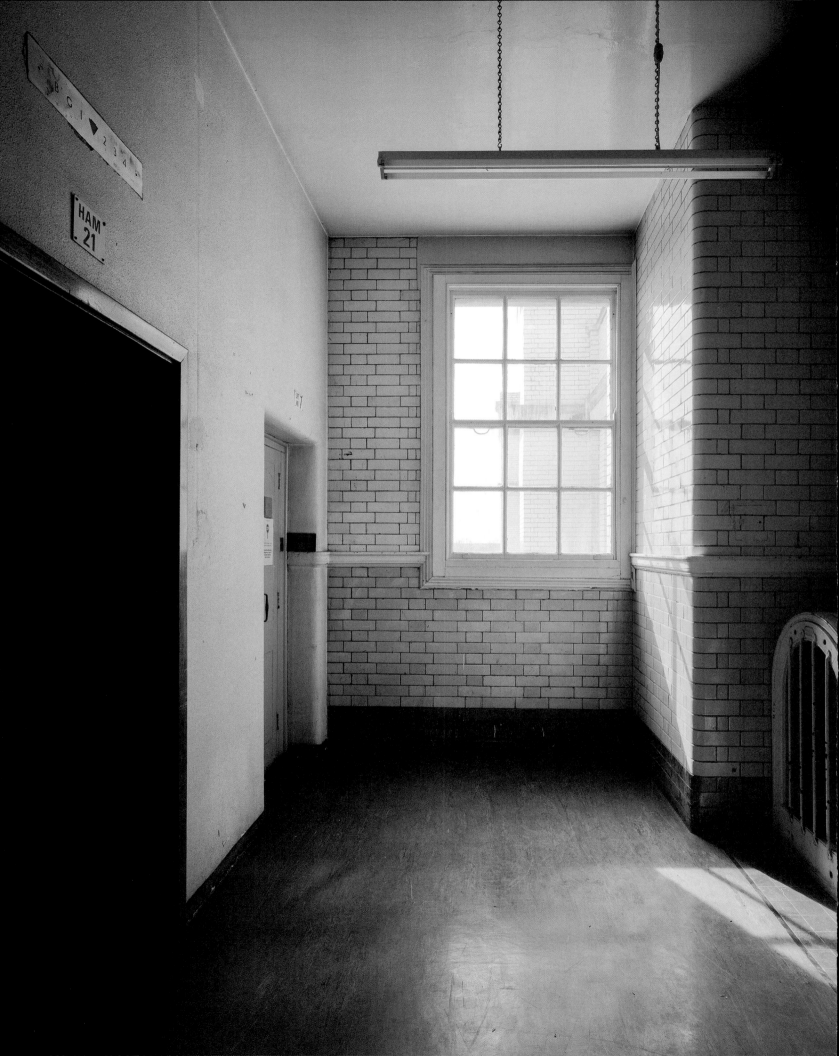

The collection varied greatly in content,
from the very modern, such as a Chinese
'Hello Kitty' purse, to 200-hundred-year-old
cheese from a village in Pakistan. The latter
still gave off such a pungent aroma that,
even though it was sealed in two bags, you
could still smell it through the closed
drawer as you passed this section.

— Ben Harridge

It was a cold and quiet place to work, quite eerie, although I usually went with another person, which also had the bonus of involving a lunch at the nearby greasy spoon (George's was it?). [Blythe] was a huge place and I only knew certain routes which took me to the metalware stores. I think these rooms weren't served by a lift, pretty annoying when metalware can be heavy to carry.

— Megan Thomas

Well, you do have strip lighting now, which is brighter. But my memories, you see, are of the old-fashioned lighting. It was very gloomy. And dirty windows! I have no recollection of anybody ever cleaning a window. It would be costly, wouldn't it?

— June Fenwick

I liked how quiet Blythe House felt when you were in the stores. I found it very relaxing. Often, I could be working alone in rooms, and people would scream upon finding me as they didn't expect anyone to be in the room. This also meant lights would sometimes get switched off while you were inside, but I was able to navigate rooms in the dark fairly well. My favourite memory was of a time I was cleaning a wax anatomical model in the basement. The model of a dissected woman was placed on a table, so the scene was similar to an autopsy. I was cleaning her with a solvent solution and paintbrush, dressed in a lab coat for the pockets, and happened to be sat cleaning her pubic area when a small tour of Wellcome staff walked past the open door. I think they all had quite a shock.

— Emily Yates

I worked with my colleagues from the textiles department and a textile conservator. We got on well. I always found the security guards friendly and welcoming – a contrast to the building, which was definitely not. I always wanted to linger in their warm and cosy office. I did not like going down those long corridors and still feel a chill when I think of them.

— Lucy Johnston

I had never worked directly with museum objects before, but I don't think any amount of training could have prepared me for the physical and quite emotional reaction I had to being left alone in the stores for the first time. After the grandeur of Blythe's exterior, the rooms I was working in (MG08, MG09 and the human remains store) seemed small, dark and cramped by comparison. If there were highly sacred objects in our collection, it felt that they should be treated with more respect than crammed into drawers and cupboards and jostling for position.

— Shelley Angelie Saggar

I was often working alone in B25: the wind
would howl under the external door and several
times a day the fire alarm would (loudly) go
off, causing an unpleasant rush of adrenalin
to course through me!

— Tim Boon

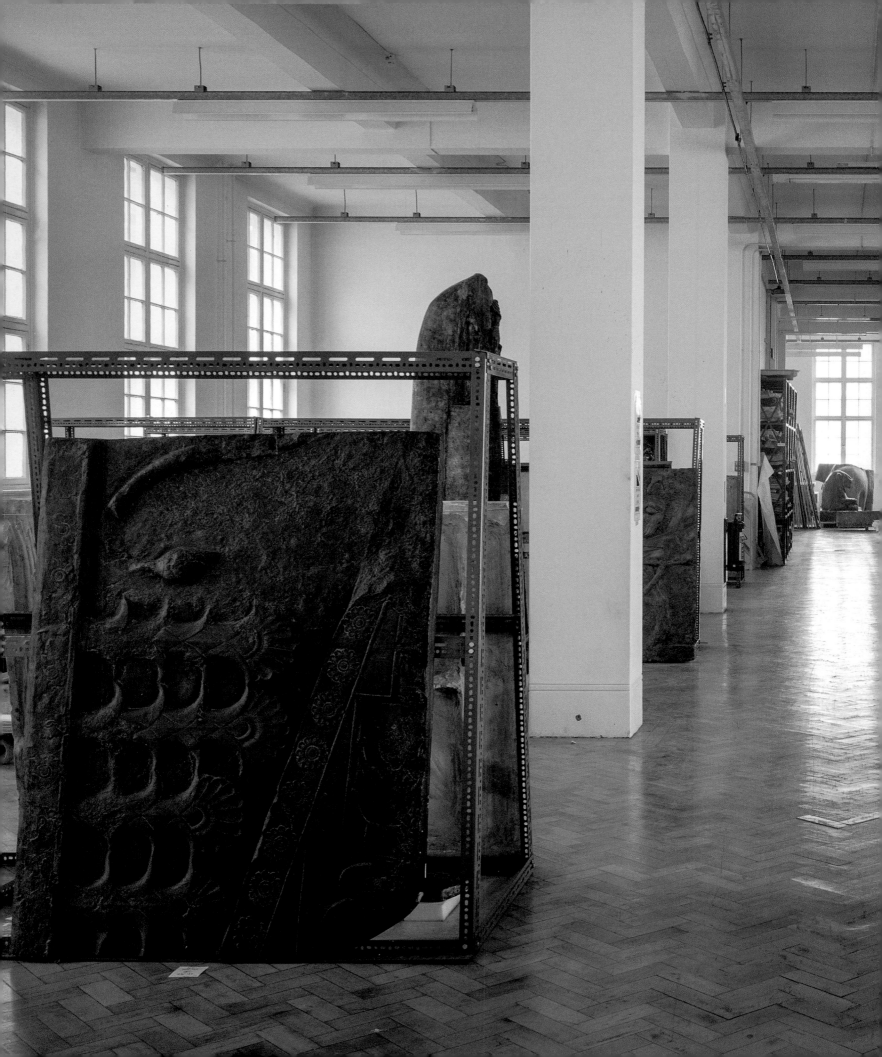

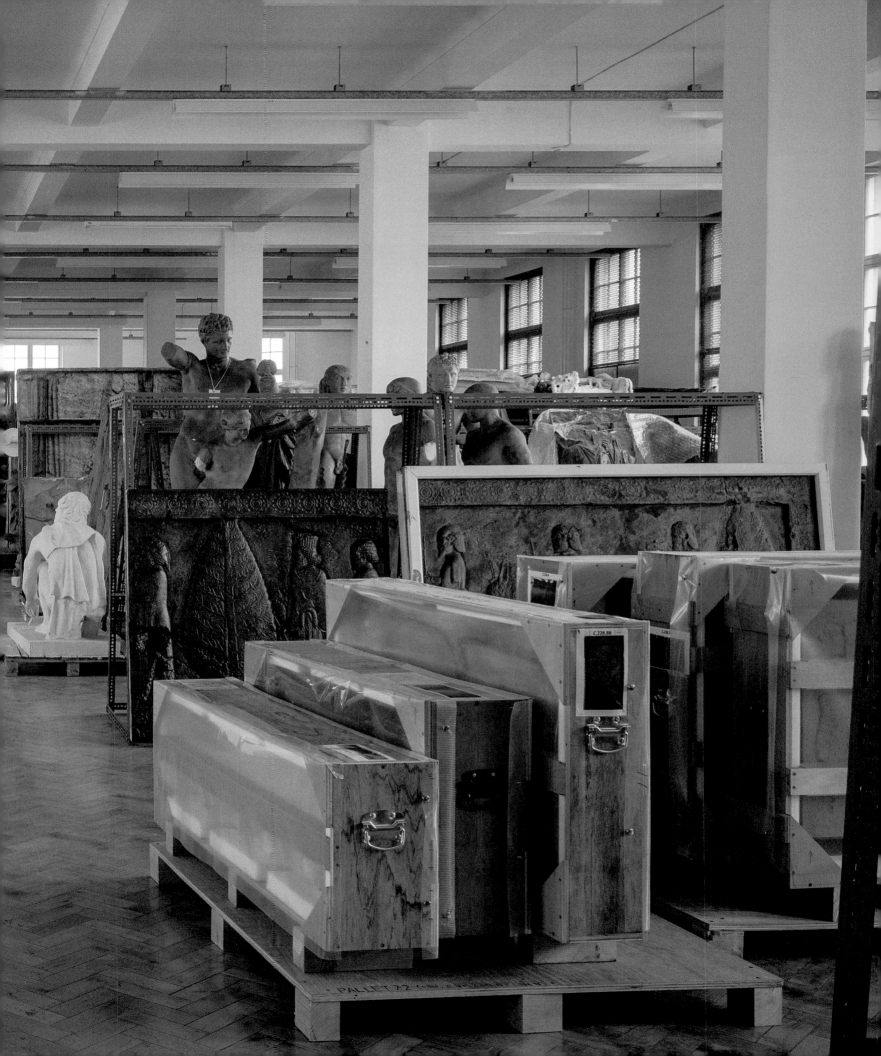

You can feel extremely alone, and be very
aware of it when working on your own for
short times on the various floors, but not
in a menacing or scary way. You just have
an awareness of it in the silence there is.
You, one small individual in a huge building.

— Hugh Walker

It can be a like a huge, haunted house! It can
be eerie. We had a light in our main corridor
that only came on when activated by movement.
At around 6pm one evening I was collecting
something from the printer (the printer wasn't
in the office that I was based in, so I had
to walk through a couple of stores to get to
it); everyone else had gone home. Suddenly,
the corridor light came on. I went into the
corridor to see if anyone was there, but there
wasn't. I felt a bit spooked and went home
soon after!

— Keith Lodwick

Before the Science Museum had a conservation
team on-site, it was my job, as assistant
stores person, to check the bug traps monthly.
The basement corridor under the front of the
building where medical collections were stored
always felt a very long way away from any
other human and gave me the creeps. The false
limbs and materia medica rooms in particular
both smelt most peculiar (in quite different
ways). When down there by myself I always
left the big metal doors between me and the
basement link block corridor open, so that if
the mad axe murderer of my imagination leapt
out, I could leg it out. I knew it was
irrational, but did it anyway.

— Jackie Britton

I grew into Blythe House, finding myself
enjoying the monumental space, and when
I think of it, I am reminded of a very
special time.

— Allison Stagg

Leaving Blythe

Leaving a place, any place, which has been an important part of your working life, is often emotional. Whether a change of location brings joy or disappointment, it is a significant moment. Just as people gave their reminiscences of their first days at Blythe House, so they were keen to give their experience of leaving it behind, and the impressions it left on them.

Between the leaving of the Post Office Savings Bank and the leaving of the three museums, there is a lot in common: after decades of these institutions inhabiting Blythe House, they were forced to move their operations far from London and begin a new era. For the Bank, that new era was as National Savings & Investments in Glasgow; for the museums, it is to their new stores in Stratford, Shinfield near Reading and Wroughton near Swindon.

But there is a sharp contrast between those who experienced the departure of the Bank, and those who were involved in the final days of the decant of the museum collections from Blythe House. The Post Office move seemed more matter-of-fact, and was linked to wider programmes of change within the Civil Service. Some people were offered the chance to relocate to Glasgow with the Bank, or were redeployed elsewhere in government, although new computerised systems of banking, which were developed at Blythe House in the first instance, meant that there were far fewer jobs available as the Bank adapted to the times.

Perhaps because we spoke to people while they were in the process of leaving rather than after they had left, feelings about Blythe House among those in the museum sector were rather different. A large number of people had formative early career experiences or training at Blythe, or had spent many years (and sometimes decades) working there, and felt enormous affection for the building and their time there. The number of people based at Blythe for all three museums grew significantly as work on the decant began, and so there is another perspective from those who were specifically employed to assist in the museum exodus.

There is pragmatism, and occasional anger, at the closure of Blythe House as a museum store. But overall, there is sadness, from people who made lifelong connections and career-changing discoveries inside its storerooms. Many acknowledge that it is the best thing for the collections, but still found it incredibly hard to say goodbye.

Well, the goal for the Post Office was to
change the way the post savings worked, from
entirely manually onto a computer system,
and save lots of jobs. At the same time,
they decided to move the Savings Bank to
Glasgow because there was then a government
policy of moving public servants out of
London. So, as it happened, the two things
went hand in hand … and then I think the
computer system was installed in Glasgow
about '67, '68. Probably '68, which was when
they began to move the operation up there.
It meant that the old system died here and
the new system grew up in Glasgow.

— John Pring

There didn't seem to be any sense of sadness.
It just happened. It was no big deal. Just
seemed so strange, but then I wasn't there to
the very end. I don't think the last of them
left until '78, and I had already gone in '74.
So, I wouldn't have seen the gold key locking
the gates. … It must have been quite sad
because I'm sure they hadn't places in the
museums for everybody. A few went to Scotland,
I think, up to Glasgow. They asked me if
I would go, but because I'd only just got
married, I wasn't going to leave London.
My family was all here. And then that was
the first time they were ever computerised,
when they went to Glasgow. Because we were all
'manuallers' you know. I never heard anything
more about what it was like to work up there.

— Maureen Mulvanny

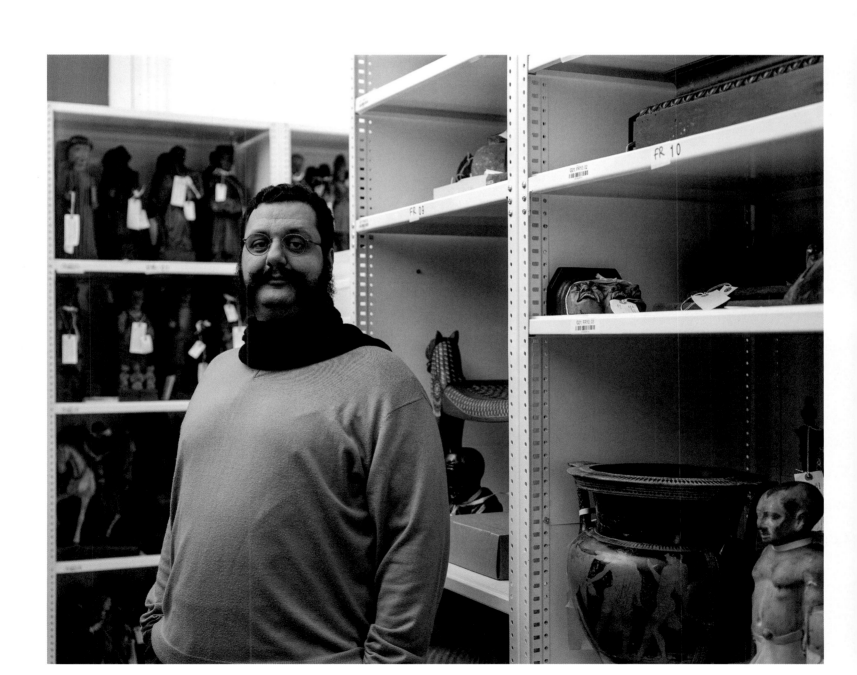

I feel like it is the end of an era with the closure of Blythe House and I feel disappointed that I won't be able to walk through the doors again. I don't think a new space will hold the same power and mystery as Blythe House did. You never knew what (or who!) you might find round a corner!

— Victoria Haddock

I feel sad, partly because it ended with the onset of lockdown rather than the gradual 'goodbye' I had planned. This is an extraordinary building, which carries so many memories.

— Veronica Isaac

I will miss Blythe immensely; I have become very attached to it over the years and have always enjoyed approaching such a magnificent building on my walk down from South Kensington station each morning. Whilst I hugely appreciate the advantages that have been offered to the collection in moving to the NCC [National Collections Centre], I will be very sorry to say goodbye to a building that has been a wonderful place to work and holds a lot of memories for me.

— Bryony Cairncross

Blythe House is both satisfactory and unsatisfactory. The satisfactory elements are that the objects are close at hand, they're accessible and viewable. It's also half an hour's walk from South Kensington … It is less ideal from the point of view of an environment for the long-term storage of objects. The fact that it's an adapted building, which was an office block which didn't have the kind of floor-loading that a museum store needs, is another debilitating factor. I think if the government hadn't decided to sell the building, I don't think we would have moved out soon, but I suspect it would still have been the aspiration … There will be new ways of doing things that will be developed, and I hope they will hold to the principles of close access to objects that we currently have here at Blythe House.

— John Liffen

THESE
GLOVES ARE
NOT AN
OBJECT

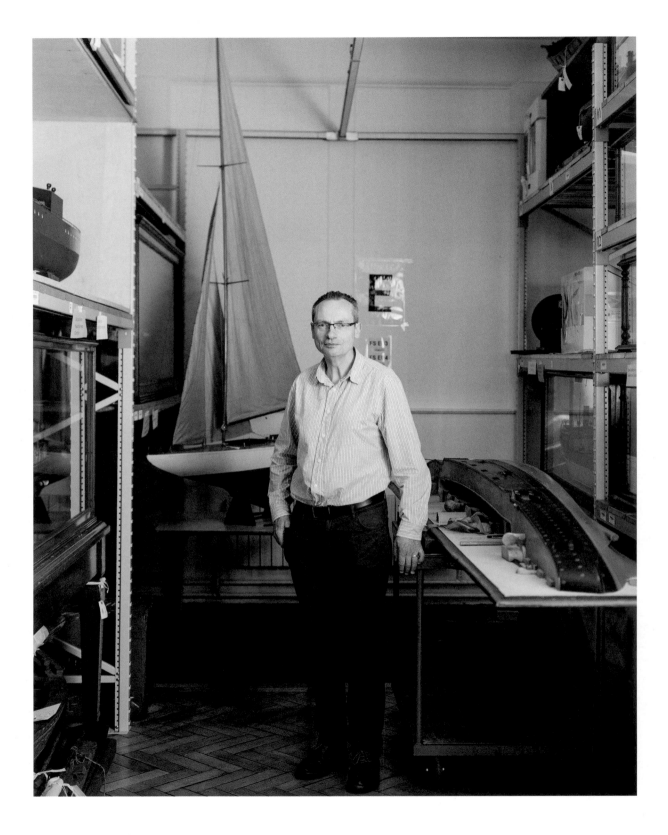

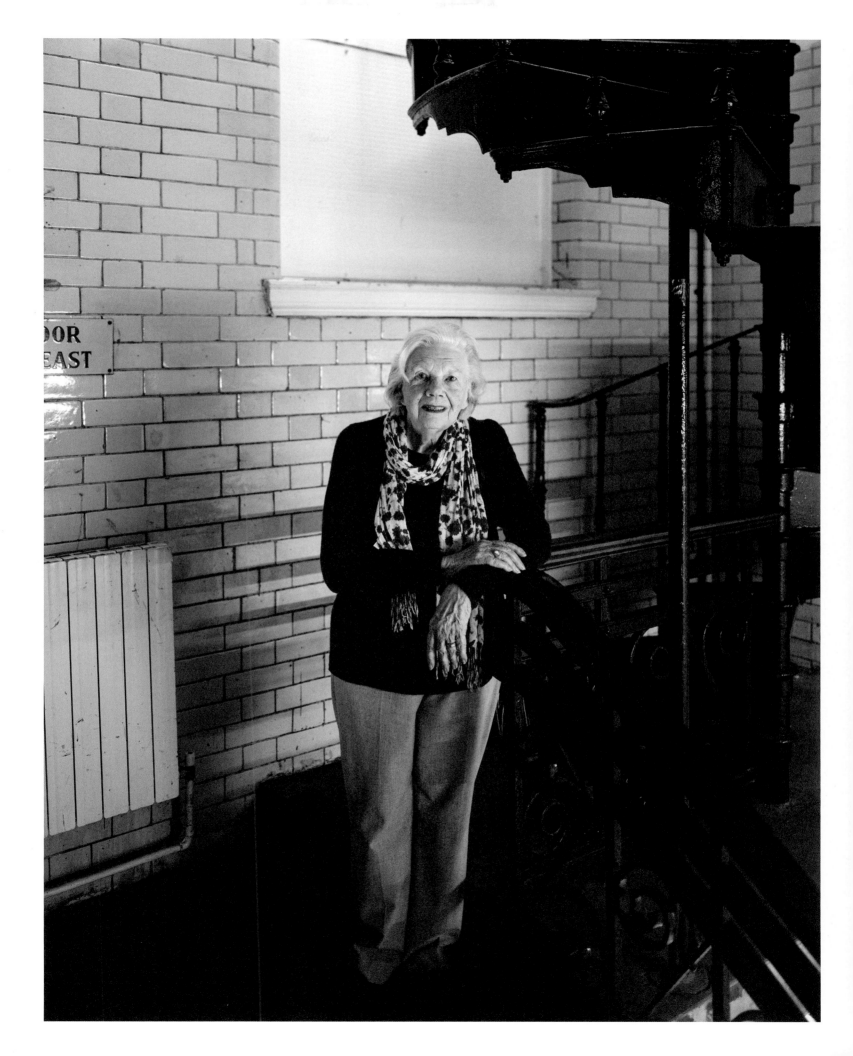

I am very, very sad to see Blythe go. It has
felt home more than any other workplace and
I have met many incredible people. Working
amongst such incredible collections *and*
beautiful architecture is a complete blessing!
I was lucky enough to begin working at Blythe
House just before One Collection [the Science
Museum's decant project] fully kicked into
gear, so I am very grateful to have experienced
it when it was incredibly quiet and then
watch it go through almost the whole journey.

— Kerry Grist

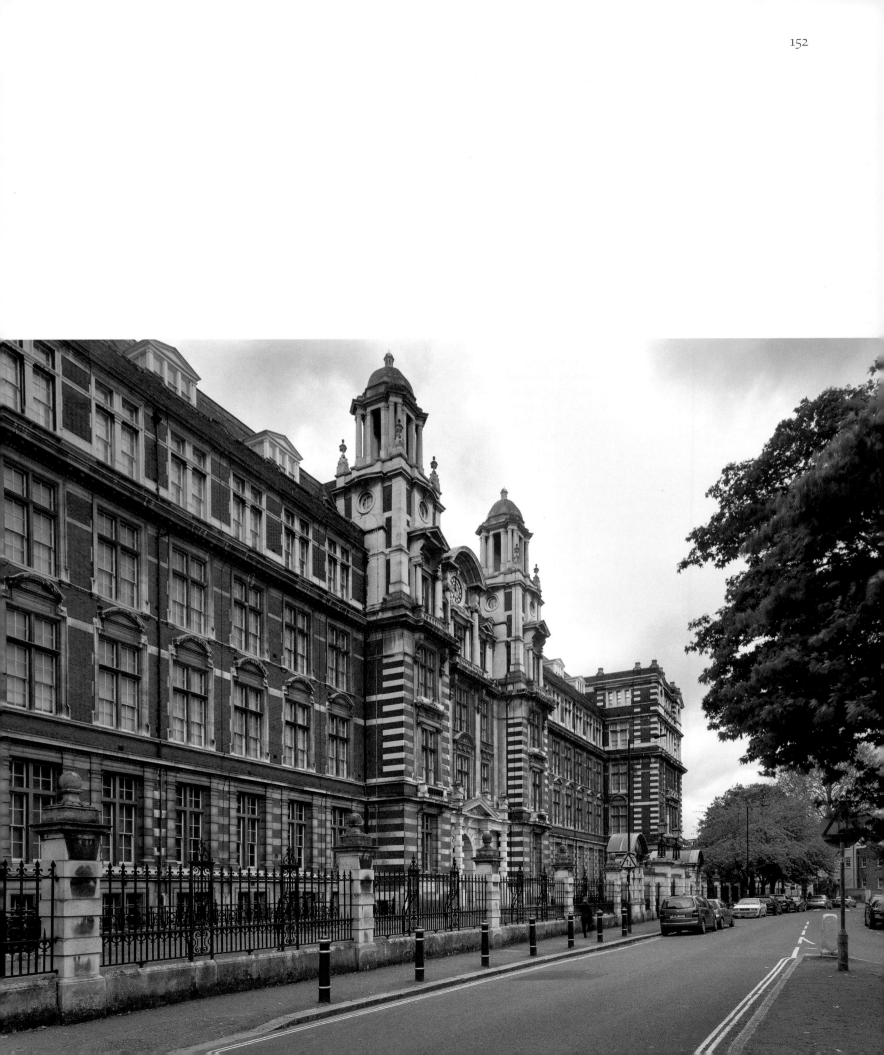

That's what I was guessing would happen.
Probably luxury flats that I won't be able
to afford. I won't be able to come back and
live here, so I will probably say goodbye
to it today.

— Maureen Mulvanny

I don't know, I'm just really sad that … maybe
it's silly, but I'm really sad it's going to
not be used for what it's been used for. I
think it's a really lovely, unique space. …
And I'm just a little bit sad. I mean, I know
buildings change and Blythe will have another
chapter. But there's a part of me that just
kind of wishes it could stay how it is now,
how there's really interesting people there,
how it's a very unique space. And selfishly we
won't be able to film in it, which is a real
shame. But you know, the bigger picture, this
very unique building is going to have the same
fate as so many of the buildings in London.

— Tom Barnes

I feel a bit sad about it, actually. I mean,
the project to get out has been successful
in one sense, in that it has brought the
three museums to work together, with DCMS
[Department for Digital, Culture, Media &
Sport], in a way that hadn't been achieved
before. … I wish that we could have found a
more common solution for where we were all
going, rather than each museum being adamant
to do their own thing. I think we could have,
you know. We did miss an opportunity. We did
talk about it but it just, it was too much,
really, for each of the institutions to
deviate from their own missions and think
of something more collaborative together.
So, there's a bit of regret there. That said,
I think what each museum is going to deliver
will be extraordinary, I'm sure, and create
amazing legacies and opportunities. So, can't
be too bitter about that.

— Karen Livingstone

CAUTION
ASBESTOS
ON ROOF DO
NOT DISTURB

I have only ever worked in Blythe House
while it is being decanted and ready to move,
so I don't know anything else. Despite this,
I'm really sad that it will be sold off to
a private firm, and the thought of it being
turned into luxury flats saddens me as much
as it angers me. I've often thought that I
wouldn't want my lovely brand spanking new
kitchen to be in what used to be a radiation
or human remains room. Although, I will be
wanting to have a look round these new flats,
even if I'll never be able to afford one.

— Rebecca Raven

I will never forget the years that I spent
at Blythe House, though it still feels like
a brilliant secret. Sometimes, I will meet a
museum curator who has been on a visit there,
or a researcher who has made some surprising
discoveries in the archives. It has invariably
made an impression on them. As for me, I never
really felt as though I left, and managed to
find excuses to pop back every so often. And
I received the ultimate Blythe House parting
gift: a registered file of my own. And so I
became deaccessioned, as the building will
be, but hopefully not forgotten.

— Guy Baxter

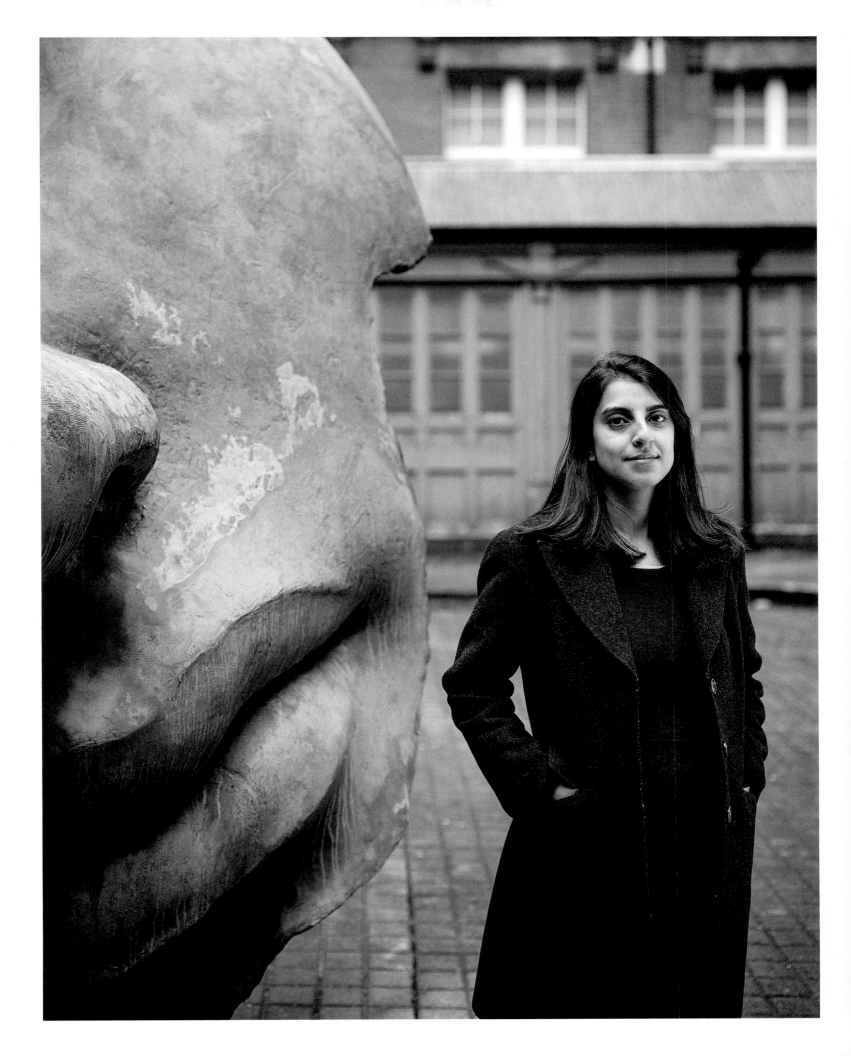

People of Blythe

At its height, the POSB employed around 4,000 people at Blythe in what, from all reports, was a bustling hive of activity. While the three museums have never reached those impressive staff numbers, their collections comprise millions of objects. As such, the hours that hundreds of staff quietly dedicate to collections care each year are in the tens of thousands. This careful and often painstaking work comes in all forms, from photographing and documenting the collections and making them digitally searchable online, through basic dusting and cleaning to more interventive conservation practices. Just over a hundred people gave some of their time to sit for a portrait, and while it was unfortunately impossible to include everyone in the book, we felt it was important to acknowledge the sheer breadth and range of this often overlooked endeavour.

Matthew Abel
Collections Moves Officer
V&A

Vanessa Applebaum
Senior Conservator
Science Museum

Jen Bainbridge
Senior Conservator
Science Museum

Sarah Belanger
Archivist
V&A

Alicia Bell
Collections Packing Supervisor
Science Museum

Jenny Benton
Collections Manager
British Museum

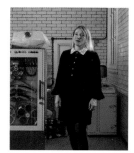

Tilly Blyth
Head of Collections & Principal Curator
Science Museum

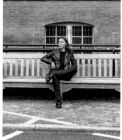

Isidora Bojovic
Photographer
Science Museum

Becca Brice
Collections Logistics Manager
Science Museum

Rhys Briggs
Object Handler & Driver
Science Museum

Laura Büllesbach
Documentation Assistant
Science Museum

Larry Carr
Collections Hazards Officer
Science Museum

Giulia Caverni
Assistant Curator
Science Museum

Laura Chaillie
Conservator
Science Museum

Inge Clemente
Photographer
Science Museum

Martha Clewlow
Assistant Curator
Science Museum

Cara Coggan
Project Manager
British Museum

Sarah Coggins
Conservator
Science Museum

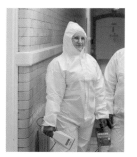

Melissa Colin
Collections Hazards Officer
Science Museum

Lucy Cope
Collections Manager
British Museum

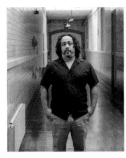

Alex Costa
ICT Software Developer
Science Museum

Miriam Dafydd
Curator Team Leader
Science Museum

Will Dave
Senior Communications Manager
Science Museum

Ruth De Wynter
Archivist
V&A

Amel Earle
Head of Technical Services
V&A

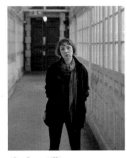

Charlotte Elliston
Conservation Coordinator
Science Museum

Alexandra Fullerlove
Head of Collections Management
Science Museum

Hattie Gaffer
Volunteer Coordinator
Science Museum

Kerry Grist
Assistant Curator
Science Museum

Melek Halil
Project Management Assistant
Science Museum

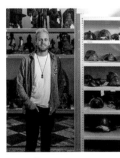

Ben Hill
Hazards Surveyor
Science Museum

Aimee Hollands
Junior Photographer
Science Museum

Harriet Jackson
Assistant Curator
Science Museum

Marisa Kalvins
Conservator
Science Museum

Sarah Kingham
Technician
V&A

Charlotte Kite
Junior Photographer
Science Museum

Mateusz Kulawik
Junior Photographer
Science Museum

Jannicke Langfeldt and
Richard Horton *Conservation
Manager* and *Senior Conservator*
Science Museum

Esme Loukota
Assistant Curator
Science Museum

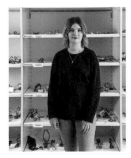

Sara Masinelli
Inventory Team Leader
Science Museum

Katie McNab
Assistant Curator
Science Museum

Tori Miller
Photography Team Leader
Science Museum

Maureen Mulvanny
Ledger Department and *Head of Registry*
POSB and V&A

John Pring
Automatic Data Processing Team
POSB

Rebecca Raven
Associate Curator
Science Museum

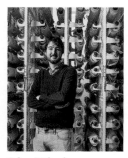

Calum Richardson
Collections Manager
British Museum

Panos Ritsonis
Object Handler
Science Museum

Freya Rock
Volunteer Coordinator
Science Museum

Jessica Routleff-Jones
Conservator
Science Museum

Anna Rowe
Documentation Assistant
Science Museum

Kay Saunders
Conservator
Science Museum

Samantha Stewart
*Head of Collections Storage & Moves
Programmes*, British Museum

Sophie Strong
Collections Assistant
Science Museum

Ryan Tennant
Cleaner & Porter
Science Museum

Katie Thompson
Hazards Surveyor
Science Museum

Bradley Timms
Junior Photographer
Science Museum

Kirsty Toth
Documentation Assistant
Science Museum

Stephanie Tredan
Documentation Assistant
Science Museum

Emma Turvey
Hazards Surveyor
Science Museum

Matt Walker
Conservator
Science Museum

Rachel Ward
Project Administrator
V&A

Adrian Whicher
Assistant Curator
Science Museum

Sarah Wilkinson
Decant Team Leader
Science Museum

Sian Williams
Programme Director
Science Museum

Jane Wilson
Collections Moves Manager
V&A

Gregor Wittrick
Assistant Collections Manager
British Museum

Contributors' Biographies

Forty-one people responded to our call-out for contributions on their memories and experiences of Blythe House, and their experiences spanned from the 1940s to the present day. Some were interviewed on-site at Blythe House, but when the Covid-19 pandemic made this impossible, we switched to gathering written reminiscences. Below is a brief biography of each contributor to *Memory Bank*. We are extremely grateful to have been entrusted with all of their memories of Blythe House.

Matthew Abel first visited Blythe House in 2012 while working for the National Art Library at the V&A, before returning in 2018 as a Collections Move Officer.

Tom Barnes is a Location Manager for film and TV, who worked on a number of productions filmed at Blythe House.

Guy Baxter worked as an Archivist and Conservation Manager for the V&A at Blythe House.

Tim Boon worked at Blythe House as a Museum Assistant 1985–89, unpacking the Wellcome collections for the Science Museum. He later became a Research Assistant and Curator of Public Health, continuing to work closely with medical collections.

Roger Bridgman was Curator of Communications for the Science Museum between 1988 and 2000.

Jackie Britton worked in several roles for the Science Museum and the V&A between 1990 and 2011.

Neil Brown worked at Blythe House as a Science Museum Curator from the 1980s to the 2000s.

Bryony Cairncross worked as Conservation and Collections Manager at Blythe House for the Science Museum.

Dennis Creasey was Boy Messenger No. 53 at the Post Office Savings Bank, 1945–56.

Terri Dendy was a Collections Assistant from 2011 to 2012 at Blythe House, working for the Science Museum.

Edwina Ehrman was the Lead Curator on the V&A's Clothworkers' Centre for the Study and Conservation of Textiles and Fashion.

June Fenwick started work at the Post Office Savings Bank in 1944 as a Temporary Clerk Grade 3. She left to work in the Treasury, before returning as a Clerk in the Establishment Branch.

Lauren Fried was a postgraduate researcher at the V&A from 2010 to 2019, during her MA and her PhD.

Kerry Grist started as a Science Museum collections volunteer, before becoming a Collections Assistant and later an Assistant Curator based at Blythe House.

Victoria Haddock was an independent researcher who worked with the Vivien Leigh Archive at the V&A during her MA.

Muriel Harding (née Sargeant) joined the Post Office Savings Bank in 1958, as an Executive Officer.

Ben Harridge was a Collections Storage Assistant for the British Museum, 2013–14.

Veronica Isaac worked in the Theatre and Performance Department of the V&A from 2009 to 2020, as a volunteer, Assistant Curator, consultant and researcher.

Lucy Johnston was a Curatorial Assistant in Textiles and Fashion at the V&A.

Lowri May Jones took on a number of roles for the British Museum in its Asia Department between 2013 and 2017.

Amy King was a Library and Archive Assistant, and an Assistant Curator, in the Theatre and Performance Department at the V&A.

John Liffen joined the Science Museum in 1969, and worked there until his retirement in 2017, when he became a Curator Emeritus. Much of John's extensive work at Blythe House was with the telecommunication collections.

Karen Livingstone first worked at Blythe House as an Assistant Curator for the V&A, and went on to lead the redevelopment of the Clothworkers' Centre there. In 2011 she moved to the Science Museum as Director of Masterplan and Estate, and was responsible for the museum's presence at Blythe.

Rachel Lloyd was Filming & Location Hire Manager for the V&A, which included responsibility for filming at Blythe House.

Keith Lodwick was Curator of Theatre and Screen Arts at the V&A, 2013–21.

Alex McDonald left school in 1950 and, after passing the Civil Service entrance exam, joined the Post Office Savings Bank, working at the Daily Balancing Branch until 1955.

Doug Millard is Curator of Space Technologies at the Science Museum. From 1991 to 1993, he was Curator Grade G, running day-to-day activities at Blythe House.

Maureen Mulvanny worked for the Post Office Savings Bank from 1962 to 1974, in the Ledger Department. In 1974 she was redeployed to the V&A. She had several jobs in the museum before returning to Blythe House as the Head of Registry in the 1990s.

Michael Potts is a chartered accountant who discovered his family had been clockmakers for five generations. Little was known about William Potts & Sons until he published his research in 2006. The firm provided the clock that still sits above the main gate to Blythe House.

John Pring was a member of the Automatic Data Processing (ADP) team at the Post Office Savings Bank, designing a new computerised system ahead of the Bank's move to Glasgow.

Rebecca Raven worked as an Assistant Curator and an Associate Curator at the Science Museum, on the One Collection decant project.

Ben Roberts worked as Curator of European Bronze Age collections at the British Museum between 2007 and 2012.

Shelley Angelie Saggar worked on the Science Museum collections, and in particular culturally sensitive objects, in 2019.

Peter Scott held a number of roles that brought him to Blythe House. He first worked as a Senior Museum Assistant on the Wellcome Collection.

Lucinda Smith worked in a number of roles and departments for the British Museum at Blythe House, 2000–16.

Allison Stagg was an intern with the Prints and Drawings Department at the British Museum.

Megan Thomas was an Assistant Curator at the V&A from 2002 to 2007.

Hugh Walker started as a Trainee Storage Assistant in 2009, before becoming a Heavy-Object Handler.

Clare Wichbold visited Blythe House as a family history researcher, looking into the life of Arno Wickbold, a motorcycle stunt driver.

David Wright was formerly a curator at the Science Museum, working primarily with the Wellcome Collection.

Emily Yates began as a Conservator at Blythe House for the Science Museum in 2012. She spent some time as Conservation Manager there, before planning and managing the collection moves for the Science Museum's One Collection decant project.

Notes on Sources

The Memories in *Memory Bank*

The aim of *Memory Bank* was to gather the testimony of people who worked at Blythe House, in as many of its different guises as possible. This project started with a number of in-person oral history interviews in 2019. These interviews were with:

From the Post Office Savings Bank days, June Fenwick and John Pring. June started at the Bank in the 1940s, and John in the 1960s. Also with experience of the Bank was Maureen Mulvanny. Maureen had the unusual distinction of having worked for the POSB until it began to wind up operations in Blythe Road, when she was redeployed to go and work for the V&A. She worked in South Kensington initially, but eventually returned to Blythe House as Head of Registry, and retired from Blythe.

From the film industry, Location Manager Tom Barnes spoke of his multiple experiences working at Blythe on film and TV productions, and Rachel Lloyd, the V&A's Filming & Location Hire Manager, told us even more about how Blythe House served as a backdrop for blockbusters, music videos and documentaries over the years.

From the museums, John Liffen, Curator Emeritus at the Science Museum and long-serving Blythe House worker, provided us not only with his own personal experience of working in the building, but also a detailed account of the Science Museum's pre-Blythe storage and the move in. Karen Livingstone, Director of Masterplan and Estate at the Science Museum, was responsible for Blythe House at the highest level as a Science Museum Group site when we interviewed her, but early in her career she had served as an Assistant Curator at the V&A, and went on to lead the development of the Clothworkers' Centre there in the 2010s.

Unfortunately, after these first interviews, the Covid-19 pandemic hit, and we had to change our approach to gathering people's stories. Thankfully, we already had a great example to follow: Dennis Creasy had been unable to come to Blythe House for an in-person interview, but had instead provided us with a thorough written account of his time as a Boy Messenger in the Post Office Savings Bank.

Taking our cue from Dennis, we switched to gathering written recollections of Blythe House, and were able to assemble a really varied selection of voices to represent as much of the building's history as possible. While frequently shorter than the oral histories (and you may notice that those who we interviewed in person are quoted more often), this allowed many more contributors to be involved in the project, and created a wider picture of what Blythe life was like.

We are so very grateful to all the contributors for their willingness to share their memories with us, and hope they bring some of the building's amazing story to life.

Archival Sources

Where the history of Blythe House falls beyond living memory, we have had to rely heavily on the archives to represent the early days of the Post Office Savings Bank.

Glenn Benson, former Site Manager of Blythe House, collected a large amount of material relating to the history of the building, dating back to the opening, and including film props, strike placards and POSB paraphernalia. This material was invaluable for researching the earliest days of the Bank.

Additionally, we were able to find a number of newspaper and magazine articles celebrating the opening of the Bank and reporting on notable events, in particular Henry Tanner's obituary, which gives details of his career: 'Died on his doorstep', *Portsmouth Evening News* (4 September 1945), p. 6.

On the women's experience of working at the POSB, and their several industrial actions and complaints about conditions, there has been comparatively little written, and we must look to primary sources: 'Girl clerk's grievances', *The Vote* (30 January 1920), p. 4; 'P.O. waitresses strike', *The Globe* (20 October 1919), p. 12; 'Strike of waitresses', *The Westminster Gazette* (18 October 1919), p. 3; 'Off for work at the London hospitals: Post Office Savings Bank girls in the Women's Reserve Ambulance', *The Sketch* (29 September 1915), p. 28.

Secondary Sources

There has not yet been a comprehensive history of Blythe House or the Post Office Savings Bank, but a number of research works have touched on aspects of them.

On the machinations of the POSB and how technology changed it, see Campbell-Kelly, Martin, 'Data processing and technological change: the Post Office Savings Bank, 1861–1930', *Technology and Culture*, vol. 39, no.1 (1998), pp. 1–32.

On the history of the Bank and its social importance, see Crowley, Mark, 'Saving for the nation', in Erika Rappaport, Sandra Trudgen Dawson and Mark J. Crowley (eds), *Consumer Behaviours: Identity, Politics, and Pleasure in Twentieth-century Britain* (London, 2015), pp. 197–212.

Further Reading

To find out more about the Post Office Savings Bank, Blythe House and some of the themes discussed in this book, here is a select bibliography:

Alvaredo, Manuel, and John Stewart, *Made for Television: Euston Films Limited* (London, 1985)

Brusius, Mirjam, and Kavita Singh (eds), *Museum Storage and Meaning: Tales from the Crypt* (London, 2017)

Forty, Adrian, *Concrete and Culture: A Material History* (London, 2016)

Morris, Peter, *Science for the Nation: Perspectives on the History of the Science Museum* (London, 2010)

Rappaport, Erika, Sandra Trudgen Dawson and Mark J. Crowley (eds), *Consumer Behaviours: Identity, Politics, and Pleasure in Twentieth-century Britain* (London, 2015)

Wilson, David Mackenzie, *The British Museum: A History* (London, 2002)

Captions

Page 19
Casts of sculpted busts and heads –
British Museum collections.

Pages 20–1
Main courtyard at Blythe House.

Page 22
Caroline Chestnutt – *Volunteer
Manager*, Science Museum (now
Imperial War Museum).

I really wanted to make this project to
acknowledge the vast amount of work that
goes into caring for museum collections.
When we see an exhibition, we can see
perhaps 20 per cent of the work that goes
into it. The rest is happening out of the
public eye, all the time, every day.

Page 25
Glazed brick exterior in what would have
been the West courtyard if the building
had been completed. Sir Henry Tanner
designed Blythe to be modular, so new
wings could be added as the POSB grew.
The East extension was completed in
the early 1900s but the West was never
added. The thought behind using glazed
bricks was to reflect light into the
courtyard spaces.

Page 26
Melissa Colin and **Vanessa Applebaum**
– *Conservators*, Science Museum
(now Natural History Museum and
V&A, respectively).

Melissa and Vanessa doing the regular
check on the radioactive materials store
on the fourth floor at Blythe House. This
really illustrates the variety and level of
skill in the work that goes into looking
after a museum collection. Thankfully,
they understood the project and were
happy to spend some extra time in the
suits after they had finished their inspection.

Page 28
(left) **Shaz Hussain** – *Assistant Curator*,
Science Museum.
(right) **Suzanne Smith** – *Clothworkers'
Centre Manager*, V&A.

Page 29
Yona Lesger – *Assistant Curator*, V&A.

Pages 30–1
Science Museum packing team
working together during the Covid-19
pandemic, in T26C – Science Museum
chemistry collections.

Page 32
Julia Sullivan – *Assistant Collections
Manager*, British Museum.

Page 33
Robin Clark – *One Collection Packing
Supervisor*, Science Museum (now V&A).

Page 34
British Museum filing cabinet in the
crate-building department.

Pages 36–8
British Museum archaeological collections.

Page 40
British Museum prints and drawings
rooms (FF10).

Page 43
Sarah Kirkham – *Hazard Team Leader*,
Science Museum.

Page 44
Science Museum shipping model (S21C).

Page 46
Adriana Francescutto-Miro – *Conservator*,
Science Museum (now *Senior Conservator*
at the V&A).

Partly due to their love of objects, collections
and colleagues, and sometimes because of
their specialised skill sets, museum workers
tend to stay within the museum sector for a
long time. However, due to increasingly
terrible pay and conditions across the sector,
often staff are forced to move regularly from
museum to museum. The minor benefit of
this for staff, is that one frequently comes
across familiar faces immediately upon
starting a new job, making these repeated
transitions slightly easier.

Page 47
V&A furniture collections in roller racking.
Some of these are being reused in the new
V&A East Storehouse building at Here
East in Hackney.

Pages 48–9
V&A Clothworkers' Centre.

Page 50
John Liffen – *Curator Emeritus*,
Science Museum. Science Museum
communications collections (F30C).

John worked at the Science Museum for
48 years, starting as an 18-year-old and
working as *Curator of Transport* and *Curator
of Communications*, before 'retiring' to the
position of *Curator Emeritus*.

'It became quite attractive to come to Blythe
House because you didn't have to – I made
darn sure I didn't do emails. The work was
to move objects about, handle objects. One
was very busy doing that. A straightforward
job to do, a lot to do and just get on with
it, but pleasant as well. And I haven't
mentioned the Object Handling team. You
could not wish for a better group of people.
It's very satisfying, working with colleagues
like that. Every new store, in museum terms,
is going to be a promised land.'

Page 51
Ruby Hodgson – *Collections Move Team
Manager*, V&A.

Page 52
Exterior of Blythe House from the corner
of Blythe Road and Hazlitt Road.

Page 55
Rachel Lloyd – *Filming & Location Hire
Manager*, V&A.

Page 56
Louisa Burden – *Head of Conservation*,
Science Museum (now British Museum).

Page 58
Science Museum aerospace collections (FF31).

Blythe's quirks influence how the objects
have to be stored. The storage affects
how curators, conservators and archivists
(re)discover the objects. Their subsequent
interpretation influences how we encounter
and understand these objects, and how we
encounter and understand our own histories.

Page 61
Packing British Museum textiles
collections (S4).

Page 62
David Godfrey – *Decant Assistant &
Object Packer*, Science Museum (formerly
Natural History Museum).

Page 65
(above) Wallpapers in the V&A collections. (below) V&A Clothworkers' Centre.

Pages 66–7
Hattie Lloyd – *Hazards Team*, Science Museum. Photographed in the 'Chicken Run'.

Page 68
Colour-coded storage map in the manufacturing machinery section of the mechanical engineering collections.

Page 69
Jessica Routleff-Jones – *Conservator*, Science Museum (now British Museum).

The Covid-19 pandemic was challenging for all the museums, which were working to tight timescales set by the Department of Culture, Media & Sport (DCMS) to move millions of objects out of Blythe House. Both busy shared spaces and the individual museum spaces had to be carefully managed. Here, Jessica is working in what is usually the staff break room, which is laid out in a socially distanced manner.

Page 70
Chinese and Japanese textile samples in the Clothworkers' Centre – V&A.

Page 71
Alice Foreman – *Collections Manager*, British Museum.

Page 73
Jeanette Plummer-Sires – *Project Curator*, British Museum.

Page 74
Sculpture *Tsuki-No-Hikari* (1991) by Polish artist Igor Mitoraj, stored in the main central courtyard at Blythe House. The piece is part of the British Museum's collections.

Page 75
Lisa Kennedy – *One Collection Curator Team Leader*, Science Museum.

Page 76
Philippa Mackenzie – *Head of Collections Move Programme*, V&A.

Page 78
Tom Matthews – *Collections Manager (Heavy)*, British Museum.

Page 79
Sarah Carr – *Assistant Collections Manager*, British Museum.

Page 80
Tim Stanton – *Assistant Collections Manager*, British Museum.

Page 82
Basement corridor signage – Science Museum.

Page 85
Casts of sculptures – British Museum collections.

Page 86
Goods lift lobby, third floor.

Page 87
Glenn Benson – *Building Manager*, Blythe House.

Page 88
Jessica Bradford – *Keeper of Collections Engagement*, Science Museum.

Pictured in T26C with the astronomy collections where she began her Science Museum career, Jessica became Head of Collections & Principal Curator for the Science Museum Group in 2022.

Pages 90–1
British Museum textiles collections (F1).

Page 92
Rosa Denison – *Hazard Surveyor*, Science Museum.

Page 94
Handwritten note found in the Science Museum collections. This is a good example of the sorts of messages and Post-it reminders found throughout all the museum collections.

Page 97
Science Museum radio and telecommunications collections and the Blythe House conservation studios to the right.

Page 98
Bryony Cairncross – *Conservation Manager*, Science Museum.

Page 100
Gilbert Collections – V&A. The fox parts are moulds for casting pewter.

Page 103
Alexandra Strachan – *Collections Storage & Installation Planning Manager*, V&A.

Page 105
Radiation stores – Science Museum.

Page 106
Ramona Reidzewski – *Head of Collections Management (Theatre and Performance)*, V&A.

Page 107
Jonathan Newby – *Managing Director*, Science Museum.

Page 108
Bookbinding and paper conservation tools – British Museum.

Page 109
Sealed shelf housing objects containing asbestos in an unknown state. Asbestos is a group of naturally occurring fibrous minerals, widely used in manufacturing and construction until it was discovered that it caused and contributed to a number of (often fatal) diseases and illnesses. Asbestos can be woven, bonded to other materials to strengthen them, has brilliant insulation properties and is highly fire resistant. Due to this flexibility, much of the Science Museum's collections contain asbestos in some form. It was banned in the UK in 1999.

Pages 110–11
Much of the signage around Blythe points to its long life and many uses – it layers up like a palimpsest as you walk through the corridors. This particular sign dates from the POSB days, when staff could take their lunch break on the roof. During the oral history interviews there was much reminiscing about sunbathing on the roof and the rifle club that used to have a range there. Blythe House building manager Glenn Benson amassed an archive of documents and ephemera during his 22 years as chief custodian of the building. In the Blythe House archive there are also 'fake' No Smoking signs from various film productions such as *The Hitman's Bodyguard* (2017). Added to this, there are many forgotten notes from curators and collections managers to other colleagues, on notepaper (page 94) or Post-its (page 147), about the current state of a job, or how far through sorting a particular shelf they were at the time.

Page 112
Mary Freeman – *Head of Photography*, Science Museum.

Page 115
British Museum archaeology collections in the basement.

Page 116
Donata Miller – *Assistant Curator*, Science Museum (now V&A).

Donata now works as an Assistant Curator at the V&A. Many Blythe staff moved between museums, and there were several instances when it was possible to photograph staff in multiple museum stores. This interchange of knowledge forms another aspect of the decant project.

Pages 118–19
Staff water bottles left in the corridor outside the mezzanine door in the Science Museum section of Blythe. Obviously, it is important to have access to water while working, particularly given Blythe's lack of insulation/ temperature control. The building can be too cold to work in during the winter months and the Science Museum recorded fourth-floor temperatures well over 30°C in the summer. However, given the building was never designed as a museum store for three separate organisations, welfare facilities were limited, and most were shared facilities near the entrance of the building – keeping food (and therefore pests) well away from the collections. This was the best compromise to access drinking water in the Science Museum section, which had no separate kitchen or drinking water access. Individual staff would sometimes play jokes on each other, or stick things to their own water bottles as a way of identifying them, and this in turn meant that you could often tell who/ how many people were in each room.

Page 120
Stored Chinese and Japanese textile samples in the Clothworkers' Centre – V&A.

Page 121
Archival boxes (in imperial sizes) – British Museum.

Page 122
Rolled, stored textiles – British Museum.

Page 124
Detail of a lion's head on a cast-iron drainpipe in the 'Chicken Run' at Blythe House.

Page 127
Tom Barnes – *Location Manager*.

Page 129
Christie Yates – *Collections Manager (Heavy)*, British Museum.

Pages 130–1
Catalogue card system for the furniture stores in the V&A collections.

Page 132
North-east stairwell.

Page 133
Map of Grime's Graves dig site, Norfolk – British Museum.

Pages 134–5
Theatre and Performance archives – V&A.

Page 137
Karen Livingstone – *Director of Masterplan & Estates*, Science Museum (formerly V&A).

Karen also worked at the V&A in multiple roles, including as a Senior Curator and Head of Projects, and played a big part in the redesign and implementation of the Clothworkers' Centre project.

Page 138
Deborah Sutherland – *Collections Storage & Installation Planning Manager*, V&A.

Page 139
Vanessa Shaflender – *Collections Logistics Coordinator*, Science Museum (formerly V&A).

Vanessa chose to be pictured in the V&A furniture collection as she also worked at the V&A as a Decant Officer, followed by Assistant Curator for a year before starting at the Science Museum.

Pages 140–1
British Museum cast collections (F1).

Page 145
Luca Gaavasci – *Junior Photographer*, Science Museum.

Page 147
Museums collect a huge variety of materials, objects and arcana. As a result of the increasing speed of technological and cultural change, museums with active collecting policies have started to acquire many objects with more contemporary provenance. This is particularly true of the Science Museum, where this image was taken.

Page 148
Nick Molteno – *Documentation Officer*, Science Museum.

Nick had worked at the Science Museum Group for nearly 15 years, at both the National Railway Museum and the Science Museum. He started his working life as a boatbuilder, working at the docks in both the UK and the USA, before retraining in archaeology. The ship models were the ideal part of the collection to reflect his interests and passion, particularly the half-model used as a design test during shipbuilding.

Page 149
June Fenwick – former *POSB Clerk* in the Establishment Branch.

Page 150
Leather bindings – V&A collections.

Page 151
More temporary signage in the goods lift lobby.

Page 152
Exterior of Blythe House from the centre of Blythe Road.

Pages 154–5
Exterior of the Blythe House huts within the grounds of the building. When it became clear that funding the West wing of the building was going to be difficult, the space allocated for it was populated with 'temporary' structures. These were shared between the museums, but gradually fell into a poor state of repair so were often used only for the most stable of objects.

Page 157
Shruti Chhabra – *Assistant Building Manager*, V&A.

Acknowledgements

First and foremost, we can't thank enough the people who have contributed to this project, whether by having their portrait taken, being interviewed or sending their written recollections of Blythe. The fact this project exists at all is entirely down to you and we can't overemphasise this. There are too many of you to thank individually, and for that we can only apologise. We hope that we have done your stories justice, and that you'll agree that it was worth trying to collate them into this crazy, arty, imperfect document of everything this building is and what it was like to work in it.

Thank you to all our colleagues at Blythe House who have patiently endured us appearing in random corridors to examine a staircase or photograph the tiles, while they worked around us to deliver the enormous task of decanting the collections. Thank you to Sian Williams, Jonathan Newby and Shri Mukundagiri at the Science Museum, and all of the staff involved in the One Collection project (the Science Museum Group's collections move out of Blythe House). They did not need to support any activity beyond the lifting and shifting of 300,000 objects, but we are glad they saw the value in doing so.

Thank you to the decant leaders at each museum when we embarked on this project – Alex Fullerlove, Philippa MacKenzie and Sam Stewart – who all agreed to let us make this book, despite the mammoth task of clearing Blythe House that lay ahead of them being a very valid justification to say 'no' to any additional distractions. Thank you to Nicola Clements, Katie McNab, Martha Clewlow and Melek Halil for their support in the early days of this project. Thank you to Ben Russell for letting us use his amazing drawings of Blythe House, and to Michael Potts for his history of William Potts & Sons Clockmakers and the clock they made for Blythe House. Thanks also to Richard Dunn and Wendy Burford for their feedback and comments, and to Linda Lundin, Linda Schofield, and Jenny McKinley and everyone at Scala who helped us get this mad book over the line.

From Kevin: It takes a great act of trust and collaboration to make a portrait and it's an incredible gift to receive as a photographer. Every single interaction I've had while making these portraits with you all has been a real privilege.

There are always so many more people involved in making a book than the names on the cover, and being a photographer is also far more of a team game than many would assume. Hugest of thanks to the many collaborators, editors and sounding boards who have kept this project moving. There are so many of you but special thanks go to Carl Bigmore, Maria Tzili and Damian Hughes. Thanks to my Science Museum sisters, Jennie Hills, Isi Bojovic and Alexa Philips, for putting up with my moaning and always being there to help edit, sequence and talk me off a ledge. Thank you to Mary Freeman for your unwavering support as a manager and friend, and your constant belief in this monster of a photo project, and to Kira Zumkley for giving me a shot (pun intended) at this museum photography thing in the first place. Frankly, all your names should be on the cover too! Thanks to Sian Hughes – I'm sorry I'm a nightmare!

From Laura: I've made lots of great friends at Blythe House (including some mad photographer called Kev) – thank you to all of you for your tea and sympathy in the mess room, your cheerleading for this book and for calling the basement phones

to check I was still alive down there from time to time. In particular, thank you to Emily Yates, Terri Dendy, Caroline Chestnutt, Alex Fullerlove, Selina Hurley and Miriam Dafydd for keeping me relatively sane in some of Blythe's hairiest moments. And thanks to Matt, Mum, Aneirin and Fenway for your support, especially as the deadlines (including maternity leave) started to hurtle towards me.

One person in particular was mentioned more than any other in people's recollections during this project, and is clearly as universally beloved as Blythe itself. Glenn Benson was the Site Manager at Blythe House from 1999 to 2020, and knows it better than anyone else. Not only was Glenn an enormous help in securing access for photography and interviews, and an expert reader for the final draft, but he has also amassed a collection of archive material and objects over the years representing Blythe's history that he very kindly let us use for the book. We couldn't have done it without him, and so it is to Glenn this book is dedicated, with much love and gratitude. Not just from us, but from all who have shared his enthusiasm for such an extraordinary place.

First published in 2023 by
Scala Arts & Heritage Publishers Ltd
305 Access House
141–157 Acre Lane
London SW2 5UA, UK
www.scalapublishers.com

In association with
Science Museum Group
Science Museum, Exhibition Road
South Kensington, London SW7 2DD, UK
www.sciencemuseumgroup.org.uk

ISBN 978-1-78551-502-6

Project manager and copy editor: Linda Schofield
Designer: Linda Lundin

Printed in Italy

10 9 8 7 6 5 4 3 2 1

Frontispiece: South-west stairwell, Blythe House

Front cover: *Tsuki-No-Hiraki* (1991) by Igor Mitoraj in the
central courtyard, Blythe House

Back cover: Melissa Colin and Vanessa Applebaum
complete their inspection of the radioactive materials
store at Blythe House

Endpapers: Ben Russell

Pages 4–5: Science Museum aerospace collections (FF31)

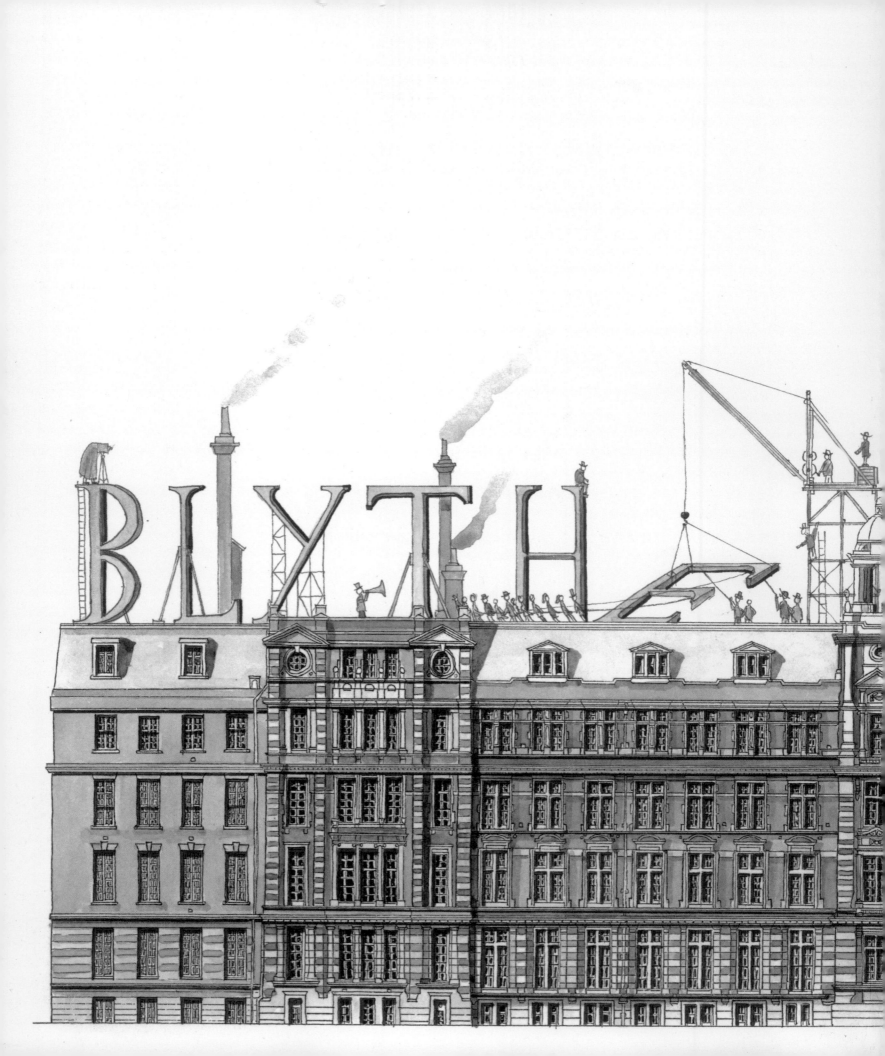